TRAMORE

ANDY KELLY & FRANK O'DONOGHUE

The History Press

Dedicated to the memory of the late Bill Irish MA,
lecturer, historian and friend

First published 2017

The History Press Ireland
50 City Quay
Dublin 2
Ireland
www.thehistorypress.ie

The History Press Ireland is a member of Publishing Ireland,
the Irish Book Publishers' Association

British Library Cataloguing in Publication Data.
A catalogue record for this book is available from the British Library.

ISBN 978 1 84588 998 2
Typesetting and origination by The History Press
Printed and bound by TJ International Ltd.

CONTENTS

ACKNOWLEDGEMENTS

We would like to thank the following for their help:

Agnes Aylward, Norma Boyle, Sean Brennan, Sylvia Byrne, Marion Cantwell, Antonette Crehan, County Waterford Museum (Willie Fraher, Michael Fitzgerald), Cumann Micheal Mac Craith (Patsy Flanagan, Charlie Ryan), Philimena and Micheal Croke, Padraig Cunningham, Grichi Gallwey McEwan, Anne Harpur, Anne Hogan, Paul Horan, Tim Howard, Irish Architectural Archives (Colum O'Riordan), Mary Jennings (née Lodge), Joan Johnson, Thomas Jones, Anne and Rhody Keighery, Mary Kelly, James Kelly, David Kenneally, Richard Kenneally, Knights of Malta (Keith Comerford, Maria Foran), Patricia Lawrence, Dick McCarthy, National Library of Ireland (Berni Metcalf), Carmel O'Regan Crosbie, Paddy O'Sullivan, Jamie O'Keeffe, Michael Power, Paul Power & John Power (Tramore AFC), Anne Reddy, Bob, Kathleen and Carrie Rockett, Breda Ryan (née Whittle), Michael Sheridan, Barry and Donal Sheerin, Andy Taylor, Laura Torrie, Tramore Golf Club (Geraldine Carbery, Jimmy Croke), Jean Tubridy-Fox, Jim Tuohy, Paul Touhy, Julian Walton, Rory Wyley, Waterford & Tramore Racecourse (Sue Phelan), Waterford City & County Archives (Joanne Rothwell, Bernadette Guest).

Anywhere in this book that a photograph is not accredited means that such a photograph is from the authors' collection.

We greatly appreciate all the assistance we received from so many people who are interested in Tramore's past and were kind enough to loan us their photographs. This book would not have been possible without such help. We apologise if we have omitted anybody's name in error. This will be adjusted in a future edition.

INTRODUCTION

As a young boy, Tramore to me meant: home, school, the Strand, the sandhills, the Rex cinema, and, above all, the train.

We came to Tramore in December 1946, when I was aged 5, and we lived in a house called 'Shirley', near the Majestic Hotel. Having come from the north Cork countryside, I found town life very congested; to my great annoyance, I was no longer allowed to run around barefoot like the country boys and had to wear shoes with laces I couldn't tie.

After my sixth birthday I was sent to the little Christ Church National School next to the Protestant church, where Miss Thompson taught all subjects. She imbued us with a love of all things Irish: I especially loved tales of Fionn and the Fianna and the songs of Thomas Moore, and I am sure that my love of Irish history is due in large part to her inspirational teaching.

We had a badly behaved terrier called Vicky. Inspired by Mary's little lamb, who followed her to school, I encouraged Vicky to do likewise. Unfortunately, I had not thought this through: what was to happen when we got there? I ordered her to go home, but she refused, so I locked her out. To my embarrassment, just as the Rector was reciting the morning prayers, she burst in the door and began licking his hand. He continued undaunted to the end, when, after a suitably pious 'Amen', he roared: 'WHO OWNS THAT BLOODY DOG?'

There were about twenty pupils of all shapes and sizes. Desmond Greer was a special friend and I thought he was so lucky that his father owned a sweet shop, until my mother explained that the sweets were there to be sold and not for Dessie to eat. Another friend, who I won't name, got me into some bad habits. We used to lie in ambush for the Christian Brothers boys who came out of school slightly later than us, pelt them with stones and then run for our lives. In fact, this lad got me into so much mischief that eventually my mother came to the school and begged the teacher to try to keep us apart. 'I was wondering when you'd come,' Miss Thompson replied. 'You're the last. All the other boys' mothers have come with the same request.'

Of the girls, Jane Doupe was my great chum. Her father was the art master at Bishop Foy's and Newtown and they lived in a big house called Westcliff, downhill from the school. I often called there on my way back from school to play in the garden. On the lawn was a huge and very climbable tree. With most trees, if you can climb them at all, sooner or later the branches become too thin to hold you and you can't get any higher. This tree, however, we managed to climb right to the top. When our heads poked out it occurred to me that a girl who could climb trees with such skill was worth hanging onto, so I asked her if she would marry me. She said that was all right with her but she would need her mother's permission. At teatime I formally asked Mrs Doupe for her daughter's hand in marriage. 'What a good idea, children!' she replied. 'But perhaps you should wait for a few years.' We did and, for better for worse, our lives took very different paths thereafter.

I had a tricycle which I was allowed to ride along the Doneraile Walk where there were no cars – until one day I was stopped at the entrance by a grumpy old man. 'Did you not see the notice?' he barked.

I had indeed seen the notice; it read in big letters: 'Vehicular – traffic – prohibited.' I had no idea what these words meant.

When I graduated to a bicycle Dermot Charles taught me to ride it on the tarmac in front of the Majestic Hotel garage. I could manage to pedal without falling off, and to use the brakes – but not at the same time. The result was that I slammed into the corrugated iron doors of the garage and was mopped up by kindly passers-by and removed bawling and bleeding to Dr O'Donnell, who stitched me together again. My mother was in Dublin at the time, and was somewhat alarmed to receive a telegram which simply read: 'Julian has split his head open.'

As if real life was not sufficiently exciting, a fantasy world awaited us in the Rex cinema. Dermot and I used to go to the weekend matinees and were occasionally allowed to go during weekday evenings. My enjoyment of the latter was spoiled by the air being thick with cigarette smoke – it's hard to speculate whether Gabby Hayes would be killed when the Indians attacked the wagons if your eyes are sore and streaming.

Tramore in winter was a ghost town – and I loved it. In the summer it filled with visitors brought out from town by our wonderful train. Almost overnight, the Strand (we never called it the Beach) was black with Gaybricks and lost its appeal – as John B. Keane said of Lisdoonvarna, it seemed to be full of bank clerks pretending to be drunk and parish priests pretending to be sober. I graduated from sandcastles and paddling on the Strand to the Boat Cove, where I taught myself to dog-paddle. When I had mastered the breaststroke and crawl I was ready for Newtown Cove and the Guillamene. Thereafter, swimming became a summer obsession, and we would set off daily with togs and towel neatly rolled up, only the foulest of weather deterring us.

The Strand, of course, provided the allure of roundabouts, chairoplanes and the occasional circus. There were bizarre characters, such as the blind man who played the accordion and Limerick Bill who always wore flowers in his hat. And there was the DUKW (known as the Duck), a Second World War amphibious six-wheeler that took us for rides up and down the Strand and then plunged into the water, scattering picnickers and bathers in all directions; alas, the hazards it provoked were too much, even for those more informal days, and one year it just didn't come back.

The Tramore train ran right past our house – only the width of the road separated us. I was fascinated by the minutiae of its operations: the puffing and groaning as it arrived in the station down the road, further puffing and groaning from the beefy men who pushed the engine round on its little turntable, its mysterious departure along a branch line and its reappearance at the other end of the train and eventual return to Waterford. Like many boys of my era, when asked what I wanted to be when I grew up I would invariably reply: 'An engine driver!'

In summertime the little engine was required to pull far more carriages than in winter. There was one glorious day when it left our station coupled to seventeen coaches (I always counted them) – and groaned to a standstill right outside our house, where it sat belching and cursing in defeat. It was almost as wonderful a day as the celebrated occasion in August 1947 when it ran away, burst through the wall at the end of the station, and plunged into the road beneath.

After my father died, my mother married Harry Kenny the solicitor, and in 1950 we moved uptown to the Kenny residence of Belair. By then I was at boarding school in England. Coming home for the holidays was always a longed-for thrill, but life was changing as I moved in one direction and my former school friends moved in others. Tramore too changed when my back was turned, and is a very different place today.

Therefore I am delighted to welcome this publication of old photographs, so lovingly compiled by Andy Kelly and Frank O'Donoghue, which brings back to me the Tramore of my boyhood, and of times long before that.

Julian C. Walton

1

EARLY DAYS

Erin's gem in the southern sea,
Glorious Tramore it must surely be,
With its golden strand and bracing air,
A treasured spot beyond compare.

This is how Tim O'Flaherty commences his poem extolling the virtues of Tramore. Even those who have just a scintilla of Irish know that *trá mhor* means 'big strand' and its anglicisation resulted in the area being named Tramore. Indeed, 200 years ago Irish was the spoken language of Tramore locals when they conversed amongst themselves. Something of a modest revival now seems to be under way and the local Gaelscoil, which is just a junior school, has 220 pupils.

It is appropriate that this first chapter should concentrate on the Strand – rarely referred to as the beach by locals – and therefore deserves capital letters.

In early times Tramore was a very small fishing village but over the years it became famous as one of Ireland's best bathing places, attracting day-trippers and visitors on holidays, as well as those who decided to take up residence there.

Bartholomew Rivers, a wealthy merchant, banker and ship-owner who was living on John's Hill in Waterford city, is credited with having been the first to embark on the systematic development of Tramore. Around 1778 he moved permanently to Tramore and went on to invest in the town by constructing terraces of houses, a market yard, an assembly rooms and the Great Hotel, later to be renamed the Grand Hotel. These were just some of his initial developments but eventually his many later investments and his distraction from the banking business forced him into bankruptcy. He went on living in Tramore until he died at an old age in 1809. However, the growth of Tramore continued and by 1814 the little fishing village had grown to 726 inhabitants, most of whom lived in thatched cottages. In 1832 the construction of a new road between Waterford and Tramore commenced. It's still

called the new road to distinguish it from the old road that runs almost parallel but not nearly as straight or wide. By then the population of the village (as it was called) had risen to 1,100 and in 1896 Tramore was officially declared a town under the Town Improvements Act. Thereafter, the growth remained steady and by the time of the 2011 Census the population had risen to the lofty figure of 10,328.

Riverstown, on the eastern side of Tramore, derives its name from Bartholomew Rivers but alas there exists no picture or plaque commemorating the man who first realised Tramore's potential and did something about it. However, as a religious man, he built a thatched chapel in 1784. This was located close to where the Catholic church is now and was the first chapel in Tramore town (see chapter 8). A few years before he died he donated a ciborium (an altar vessel), which is still in use in Holy Cross church.

It is hoped that this book will give an informative illustrated description of the steady growth of Tramore and the sheer bliss of life there.

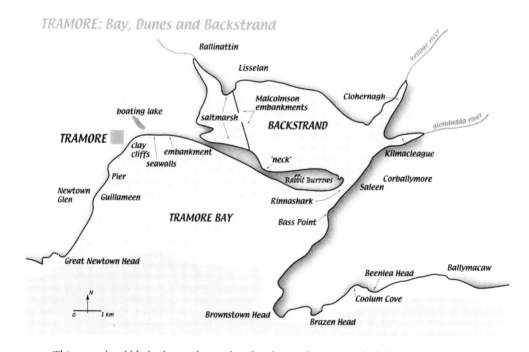

This map should help those who are less familiar with Tramore find their bearings.

The Great Irish Watering Place

TRAMORE

Is easily reached from London and North and South Wales by the G W. Steamers *via* Fishguard and Rosslare.

Through Tickets to all parts of Ireland

Tramore

IS POSSESSED OF THE FINEST — STRAND IN THE WORLD. — Also Racecourse and Golf Links, Driving, Bathing. Boating, Fishing

Visit Tramore for
Health and Vigour

From a Tramore guidebook dated 1920. Elsewhere Tramore is described as 'The Riviera of Ireland'. Sure, isn't the south-east regarded as the sunniest part of Ireland?

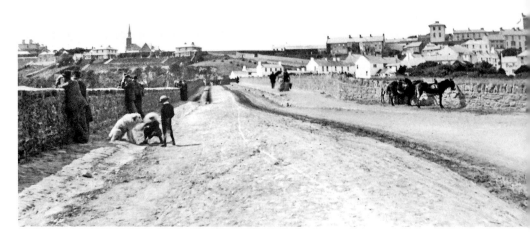

The Strand Road in 1871, with the first storm wall on the left. The tall house to the left of the Great Hotel (see page 70) was called the Turret. The area in the front centre was known as pavilion field, after the building that was later erected there. (Irish Architectural Archives)

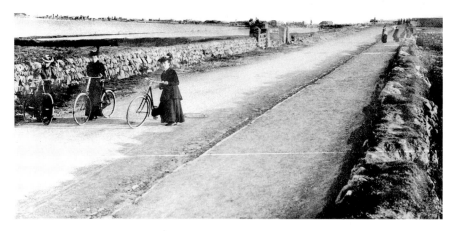

This picture of Strand Road was taken in 1890, just two years after John Boyd Dunlop had developed the first pneumatic tyre suitable for bicycles. All the area to the left has, of course, long since been reclaimed.

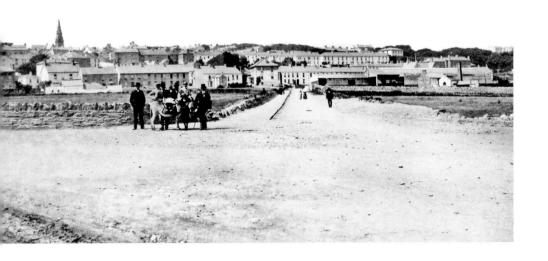

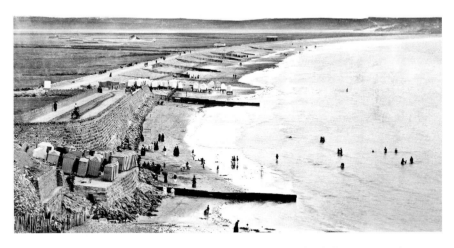

A view of the Strand showing rows of timber groynes erected to help stop coastal erosion. The Rabbit Burrows are at the far end. They run for about a mile and in places are up to a quarter of a mile wide. They were created over many centuries due to sand being blown in by the prevailing wind. The Back Strand was formed by the sea coming in through Rhineshark, which runs between the Burrows and Brownstown Head and at full tide forms a lagoon.

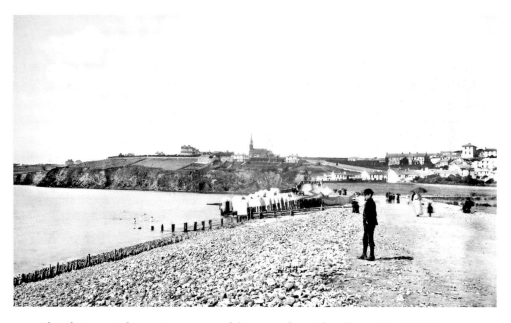

This photo was taken in 'pre-promenade' times and must have been after 1850 because Christ Church (C of I) seen in the background was completed then, but before Harney's Wall, which was built in 1893.

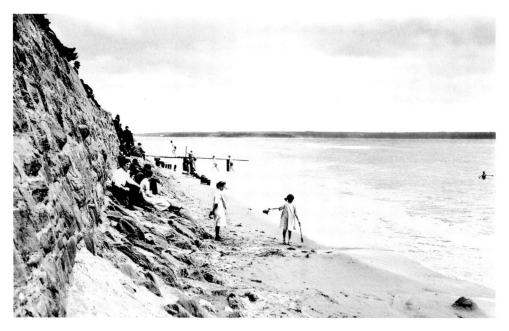

Here is the massive storm wall behind that part of the Strand where the ladies bathed. This wall was erected by the Doneraile Estate in 1837 and its height was later extended to ensure that the ladies had maximum privacy.

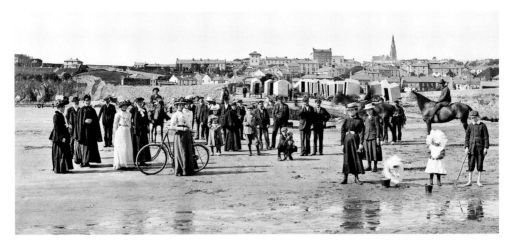

The Strand in Victorian times. Dark clothes seem to have been most popular in those days but a forward-thinking person, such as one who would invest in a new bicycle, was apt to brighten things up by wearing lighter-coloured apparel. (National Library of Ireland)

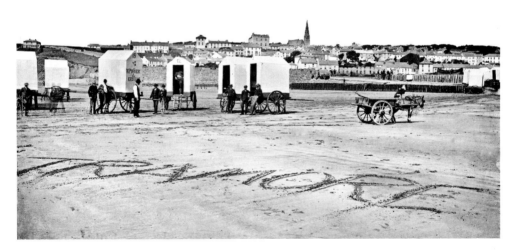

A Tramore postcard with the sand clearly labelled, probably by the photographer. One cannot but wonder how that dog manages to stay perched on the donkey's back as he hitches a ride. (National Library of Ireland)

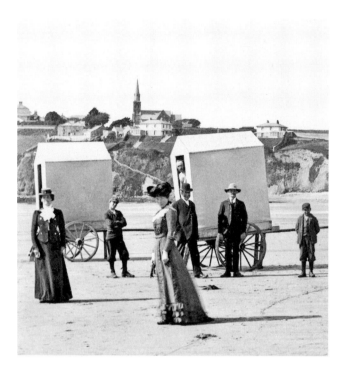

When the tide went out, the bathing boxes followed. (National Library of Ireland)

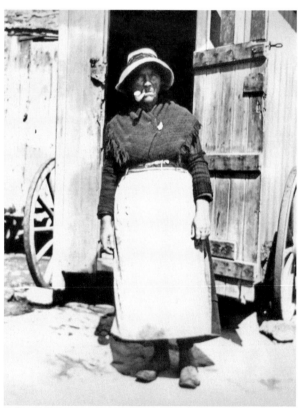

A bathing box lady with her clay pipe (a dudeen). (Andy Taylor)

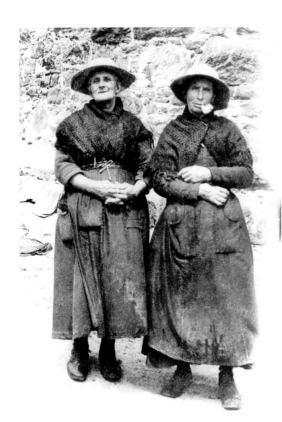

Another dudeen lover. The dudeen was a white clay pipe with a short stem. The tobacco was protected by a small silver cover with holes in it. As children, we not very successfully used dudeens for blowing bubbles – by filling them with soapy water. The pipes were manufactured in a small factory in Waterford city. (Jim Hally)

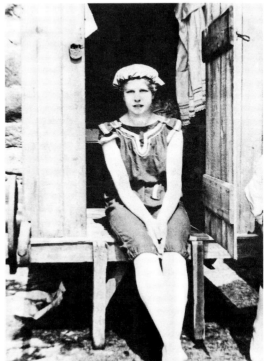

With the rented bathing box also came a bucket of water to wash the sand off your feet, as an added service. Perhaps that is what Kitty Carew is waiting for here. (Gallwey Family)

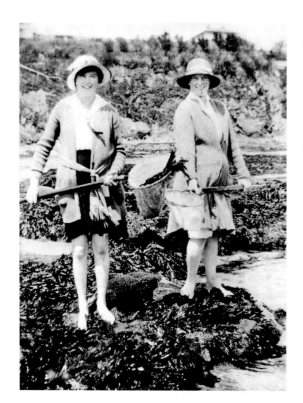

Fishing for shrimps in the rock pools under the cliff near the ladies' slip. Sometimes you would catch a small crab which was not of the edible variety. Very, very occasionally a fairly good-sized fish that had got stranded in a pool ended up in a net. (Gallwey Family)

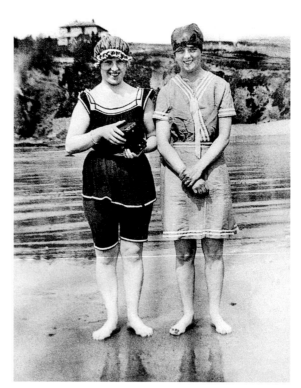

Bathing attire in 1917. (Gallwey Family)

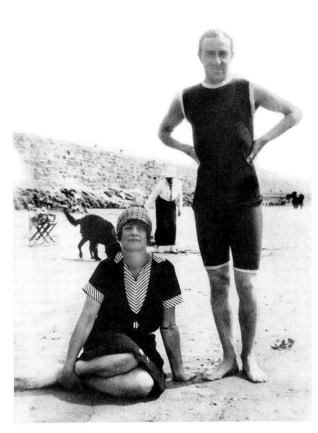

Men were also
well covered.
(Gallwey Family)

Tie, waistcoat and
jacket for the men.
(Gallwey Family)

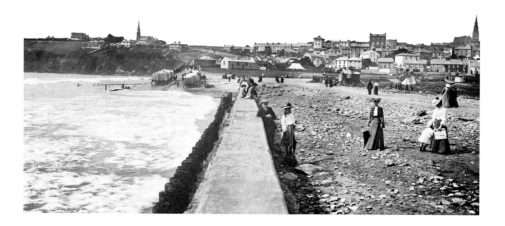

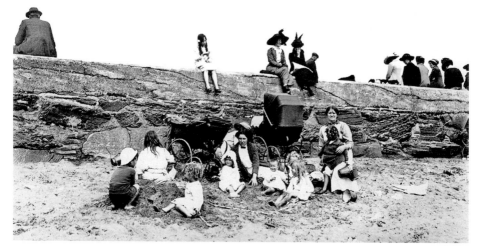

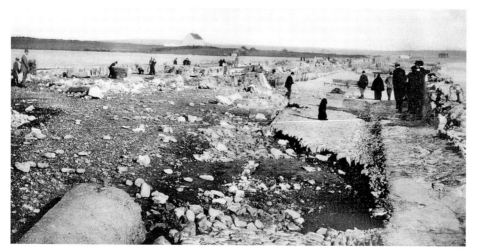

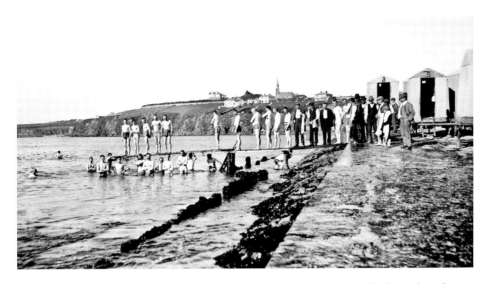

The men's slip, where at high tide it was possible to make limited use of the diving board.

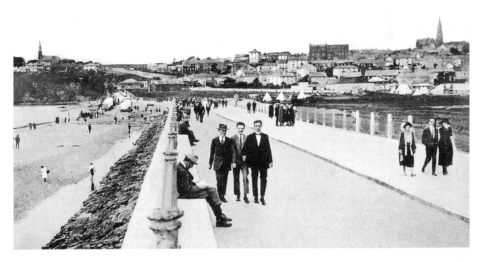

The promenade (always abbreviated to 'the prom') was completed in 1915 by builder Paddy Costen, following considerable lobbying of the Grand Jury (equivalent to the local council) by one of Tramore's leading citizens at the time, Martin J. Murphy. A stepped-back third section was built in 1932.

Opposite top: This storm wall to stop coastal erosion became known as Harney's Wall after Richard Harney who built it in 1893.

Centre: Picnickers on the beach while onlookers sit on Harney's Wall.

Bottom: A colossal storm in 1896 caused the demise of Harney's Wall.

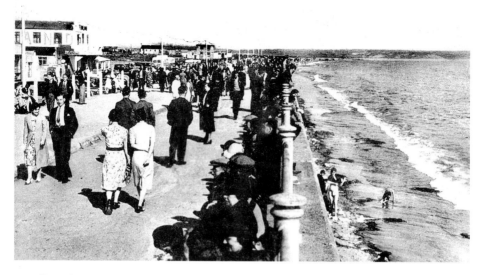

A walk on the prom became a favourite pastime of both locals and visitors. (Waterford County Museum)

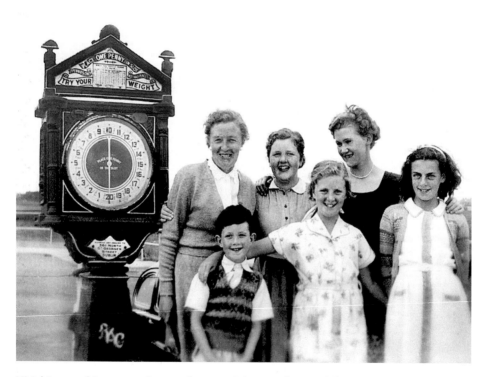

Weighing machines were always a feature of the seaside – we didn't have any at home. This fine specimen was on the prom. Some machines would print your weight on a ticket with your future destiny on the back. There was very little danger of obesity in those days. On the contrary, children where continually exhorted to 'eat up'. (Jim Hally)

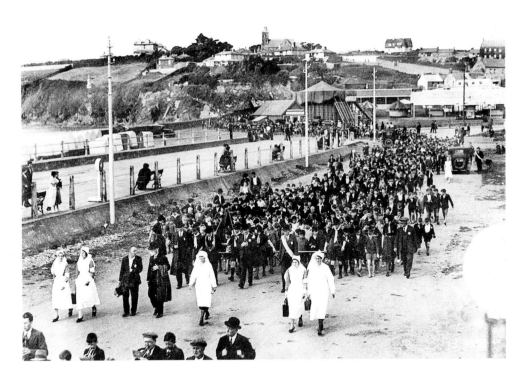

A parade of poor children having their annual summer outing to Tramore in 1932, thanks to generous support from various businesses. For about forty years in the early twentieth century as many as 2,000 children were annually brought to Tramore for a day of supervised swimming, picnicking and sport.

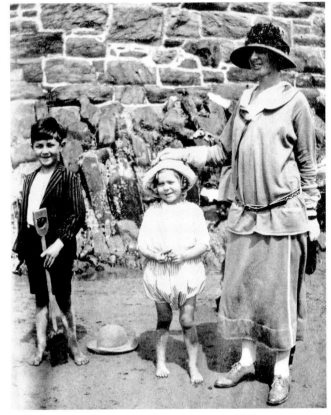

The Edwardian era saw a change of style for the women – ankles could now be visible. (Jim Hally)

And fashionable ladies wore hats like up-turned flowerpots. (Jim Hally)

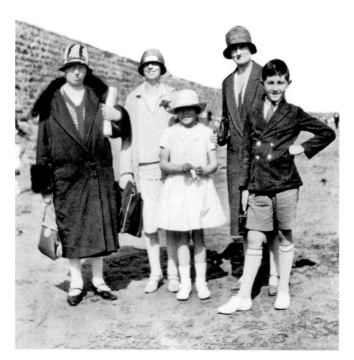

Then the hats disappeared. But look at the guy struggling to preserve his modesty while pulling up his trousers. (Jim Hally)

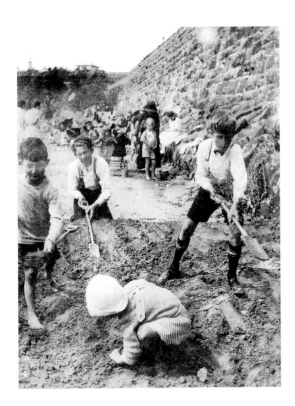

The sand is good
for castle making.
(Jim Hally)

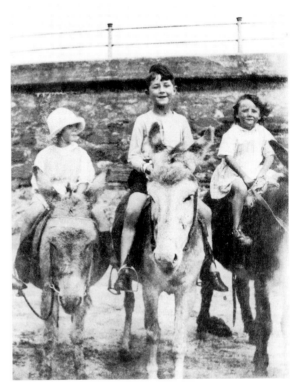

Donkeys were also
available for hire.
(Jim Hally)

One happy chappie.
(Jim Hally)

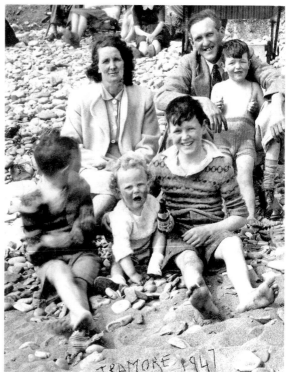

A Waterford family enjoying a day out on the beach in 1947 having travelled on the Tramore train. (Richards Family)

2

COASTAL WALKS

Now it is time to take an exploratory walk in a westerly direction along the coast and take in the very fine views, visit the rocky coves, the alternative bathing places and then finish up by having a look at some of the fine houses that were built by wealthy people who had in the 1800s decided to make Tramore their homes.

We leave the Strand and set off by going up Gallwey's Hill which takes us to a more elevated position from which we can best observe Tramore's spectacular seascape.

We will start with the Doneraile Walk, which was laid out by Lord Doneraile who had his summer residence nearby. His wife is reputed to have much enjoyed taking this walk, which was opened to the public in 1867. Simply now called The Doneraile, it is indeed a very pleasant route, overlooking the sea with seats provided for relaxing to enjoy the fabulous spectacle that is Tramore Bay.

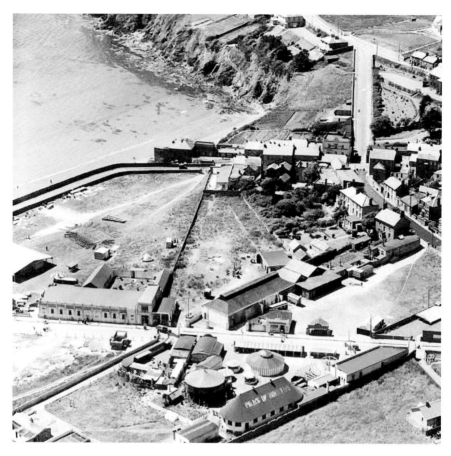

This fine aerial view of the Strand Road area in 1933 shows Gallwey's Hill going straight up and, once we reach the top of this gently sloping road, we can look back and see the vista which is 3 miles of Tramore Strand. (© Historic England)

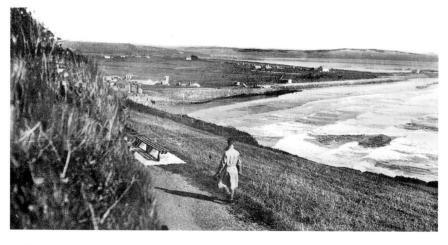

Walking The Doneraile and viewing the surf from above. (Norma Boyle)

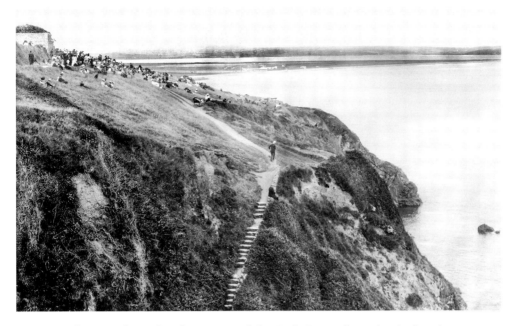

Steps down to The Foyle, where it is said that Lady Doneraile used to bathe when on holidays in Tramore. (Jim Hally)

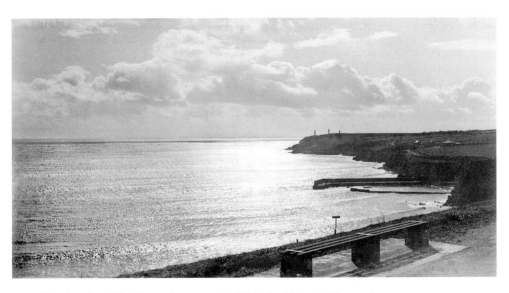

The view from The Doneraile at sunset. (Waterford County Museum)

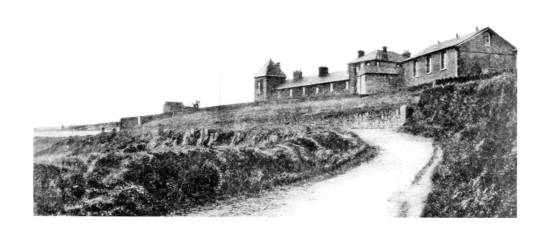

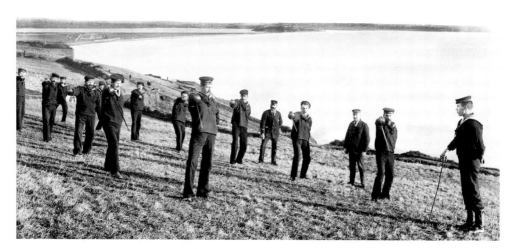

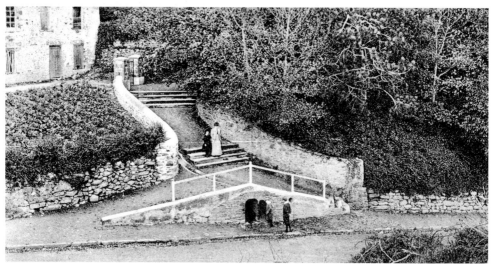

The Cove Road running past the well leads to the Boat Cove, referred to by most locals simply as 'the pier'.

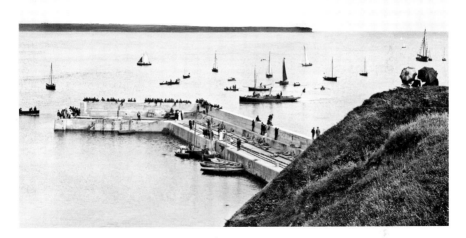

Tramore's first pier was built in 1870 but was swept away by violent storms in 1883. A new pier sturdy enough to withstand winter storms was completed in 1907. This picture was taken on Regatta Day, which used to be a major event. (National Library of Ireland)

Opposite top: The coastguard station (built in 1874 to replace an earlier one at Newtown Head) overlooking The Doneraile and Tramore Bay. For many years it served as the Garda barracks and, when they got new premises in the town centre, the Government renovated it extensively and it is now the Coastguard Cultural Centre, beside which the Tramore Branch of the Irish Coastguards have new premises which serve as their base for operations such as cliff rescue. (Andy Taylor)

Centre: Coastguard training in the old days.

Bottom: These steps run down from The Doneraile to a well that is believed to be haunted. (Padraig Cunningham)

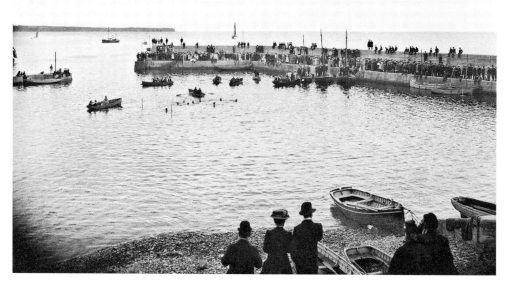

Water polo was one of the features of the regatta.

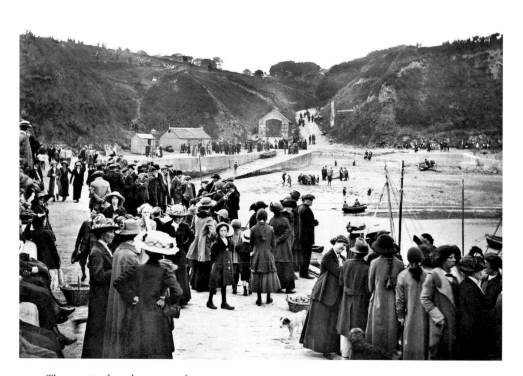

The regatta drew large crowds.

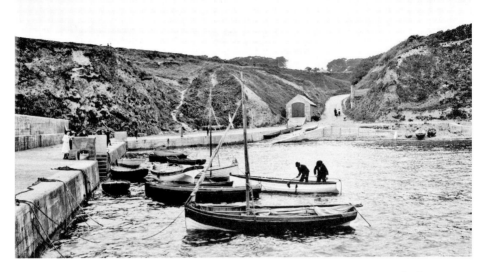

Pleasure boats at the pier. Sea rescue craft are now also housed here. (National Library of Ireland)

It is sandy when the tide goes out and it was popular to swim either off the pier itself or from the sand. (Thomas Jones)

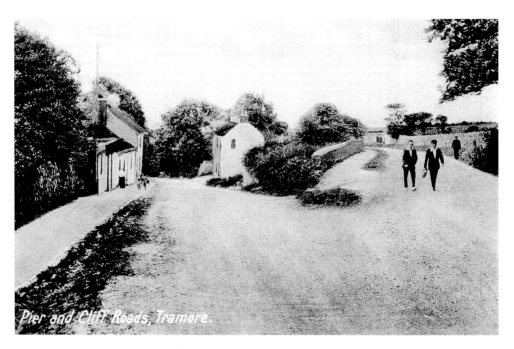

There was the option of either leaving the pier via a short cut by climbing the steps provided to Cliff Road or by walking up Cove Road (here on left) and eventually up to Cliff Road (on the right). In 1872 the Cliff Road was transformed from being a rough coastguard path by a member of the O'Neill-Power family of nearby Newtown House where, among others, the MP for East Waterford once lived.

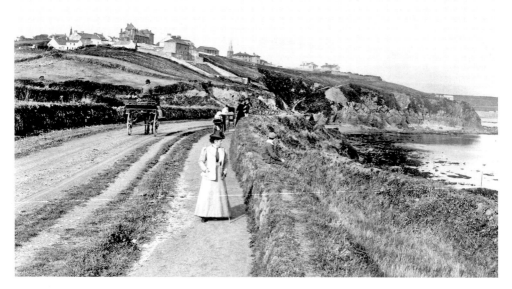

The Cliff Road is very popular with walkers and provides great sea views. The guy with the horse and jaunting car was known as a jarvey.

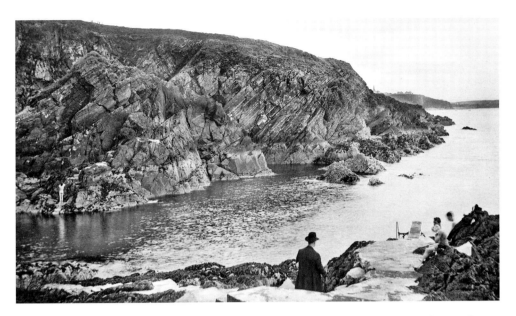

The Guillameen is further along Cliff Road and is called after the small fish that used to inhabit it. In days gone by it was a 'men only' bathing place, with most males not bothering to wear togs. That is all now in the past and good swimmers of both sexes enjoy the deep water (it is never less than 14ft) and diving board – many all year round. Christmas morning is a favourite time for the courageous to have a swim – often in aid of a charitable cause. There was a bathing place (Ladies' Cove) specifically for ladies about halfway back along Cliff Road but this is no longer in use.

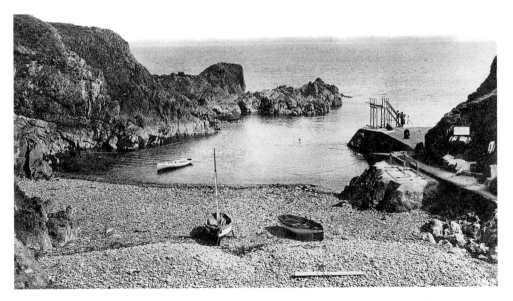

Newtown Cove is beside the Guillameen but is less challenging for swimmers either from the tiny pier or from the stony beach. It hosts an annual swimming gala and is a popular place for picnics. (Norma Boyle)

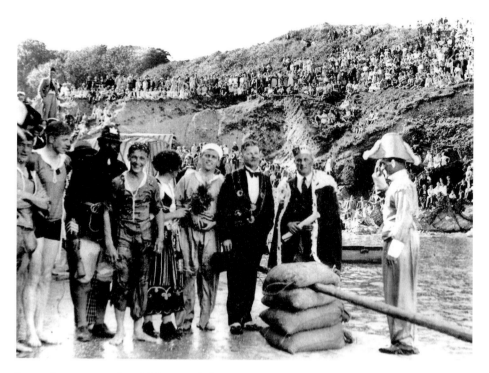

Fancy dress was a colourful feature of the swimming gala at Newtown Cove. As can be seen from the cliffs above, the gala tended to draw large crowds.

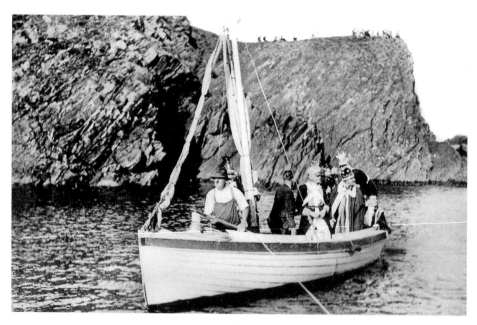

Participants also took to the water and arrived by boat into the little bay dressed in their fine costumes.

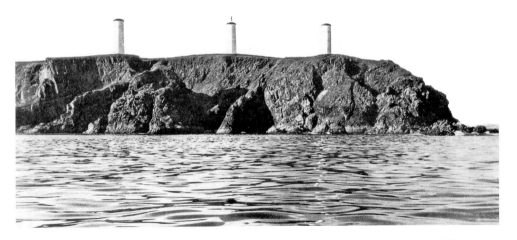

In 1821 the authorities erected two towers on Brownstown Head (to the east) and three on Newtown Head (west) to act as beacons to mark the entrance to Tramore Bay, which was notorious for wrecks. The towers are over 60ft high and on the centre tower at Newtown there stands a 14ft statue of a sailor pointing to the rocks below as a warning to ships. He is the famous Metal Man. (Norma Boyle)

Legend has it that single women who manage to hop around the base of the Metal Man tower three times without stopping will wed within a year. The ladies in this picture seem intent on early matrimony. (Irish Architectural Heritage)

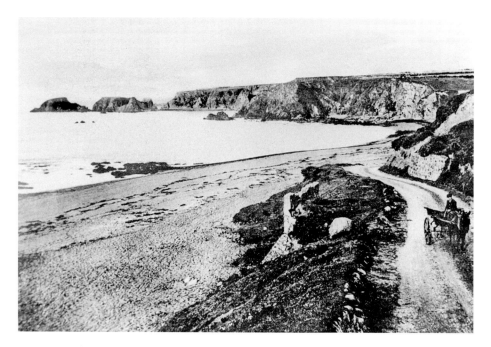

Garrarus is the cove next to the Metal Man. It is renowned for having a type of gravel that is great for laying paths. (Andy Taylor)

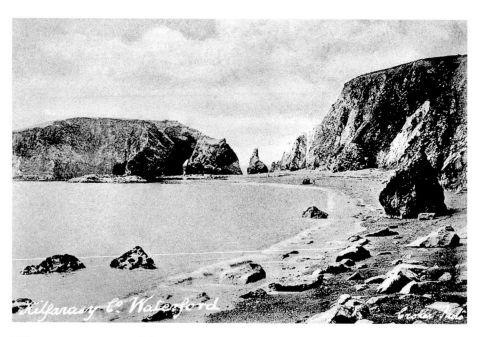

Kilfarrissey comes next and the sand is rather coarse. Next there are two tiny islands known as Islandikane (after a local chieftain) and further on are Annestown, Boatstrand, Bonmahon and Stradbally, all with good beaches. (Waterford County Museum)

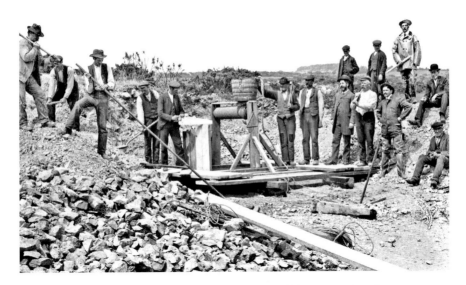

The coast road is a very scenic drive and has been named the Copper Coast because copper was once mined at Bunmahon which in those days had a population of 2,000 and 21 pubs. But alas there were terrible cases of death by starvation there during Famine years. This picture was taken at the copper mines. The mines closed in 1877.

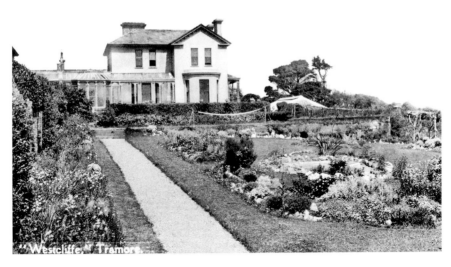

Many of Waterford's merchants decided to make their homes in Tramore, where they could avail of all the benefits of seaside living while still being within an easy distance of Waterford via the train. This beautiful residence (Westcliffe, later changed to Westpark) is on Church Road and looks out over the sea. Beside it is Rockfield. Both were designed by Abraham Denny, second son of Henry Denny who established the well-known bacon company in Waterford in the 1820s; it was Denny's that invented the rasher. Abraham was a partner in a prominent architectural practice in Dublin but quit in 1855 to return to Waterford to help expand the family firm which had then become Henry Denny & Sons. Abraham lived at Rockfield and his brother lived at Westcliffe. (Thomas Jones)

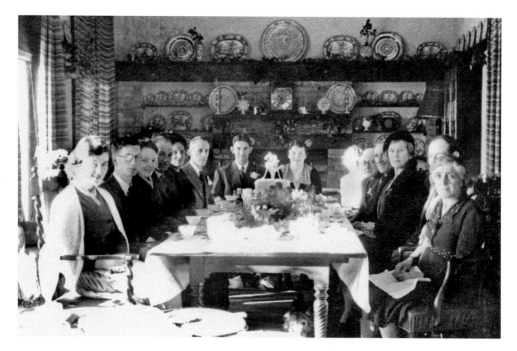

Rockfield was acquired by William Gallwey of Henry Gallwey & Co., wine and spirit merchants in Waterford and Cork. His son, Thomas H.E. Gallwey, took over from him. Gallwey's employed quite a few staff and this picture shows a staff member's wedding breakfast, which was held in Rockfield. Mrs Nora Gallwey is third from the right; Thomas Gallwey was probably the person who took the photograph. (Gallwey Family)

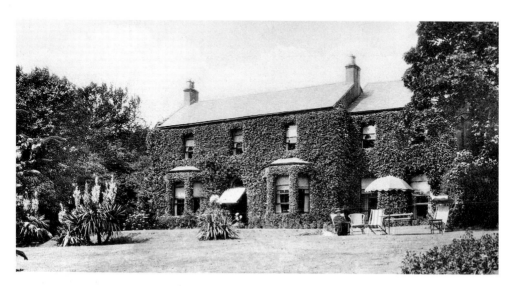

Belair, on the Old Waterford Road, was home of solicitor Harry Kenny (Kenny & Stephenson) and what a beautiful house it is. It was purchased by Elly Kedduri (a native of Bahrain) in 1970 and operated as a guest house for many years. It has now reverted to being a private family residence. (Gallwey Family)

Afternoon tea on the lawn in Belair in 1899. (Gallwey Family)

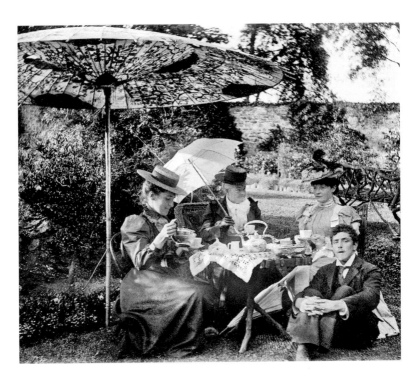

A family photo in Belair gardens. (Gallwey Family)

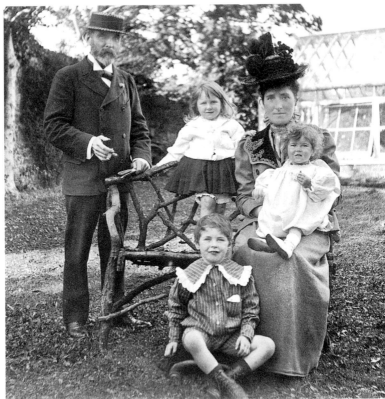

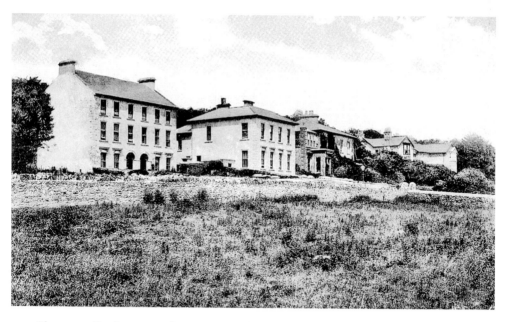

These very fine houses on the Lower Branch Road were constructed by Edward Jacob in the 1850s. (Waterford County Museum)

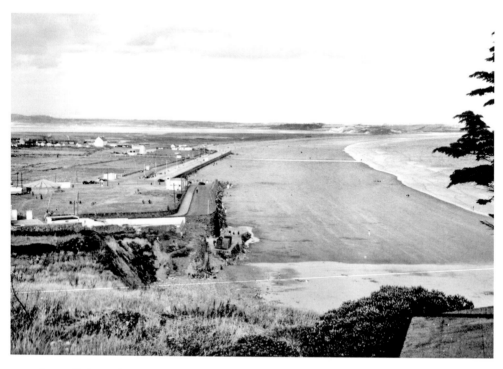

Our walk through Tramore has brought us all the way back to Tramore Strand – 3 miles of it! This handy flat surface was used for various activities that had little or nothing to do with the sea. (Mary Jennings)

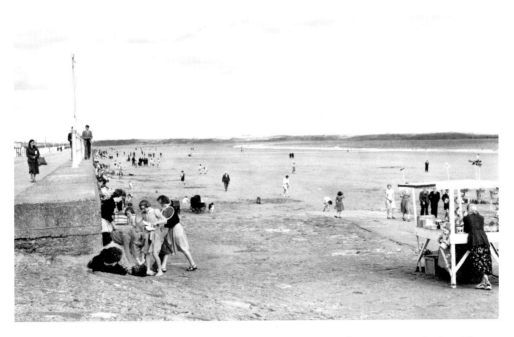

At the men's slip we see girls organising their racquets to play tennis on the beach! The lady with the little stall is selling buckets and spades, windmills and other toys of great interest to children. She does not seem to have boiling water; that was sold by the kettle-full from outside private houses close to the beach and served picnickers well in the days before the thermos flask. (Mary Jennings)

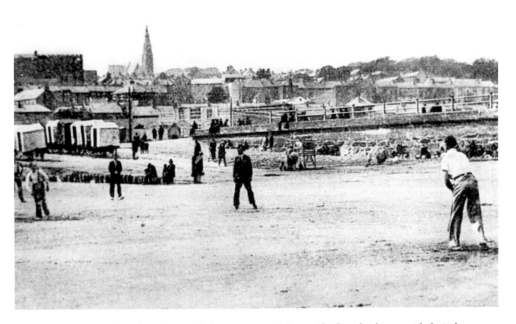

Cricket being played on the sand; in more recent times, the beach also provided pitches for annual soccer tournaments.

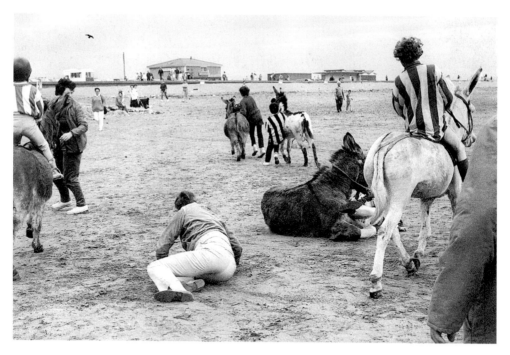

A mishap during the Donkey Derby organised by the Gaelic Athletic Association (GAA). (Antonette Crehan)

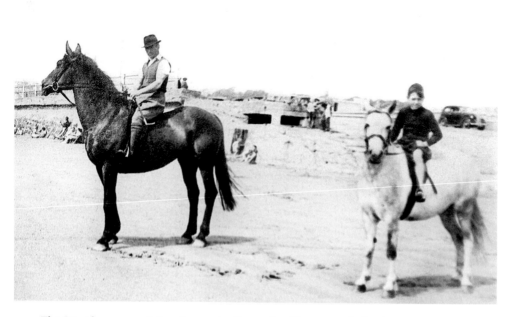

The Strand was a good place to exercise the ponies. (Antonette Crehan)

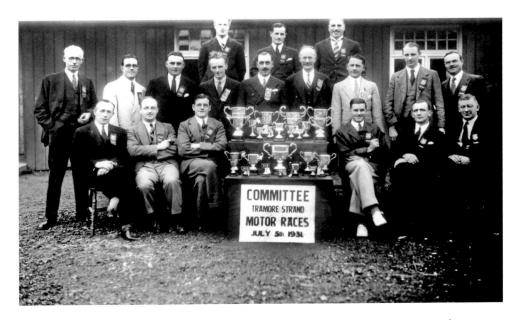

The committee behind the Tramore Strand Motor Races held in July 1931. What a fantastic array of prizes – this must have been serious stuff. (Laura Torrie)

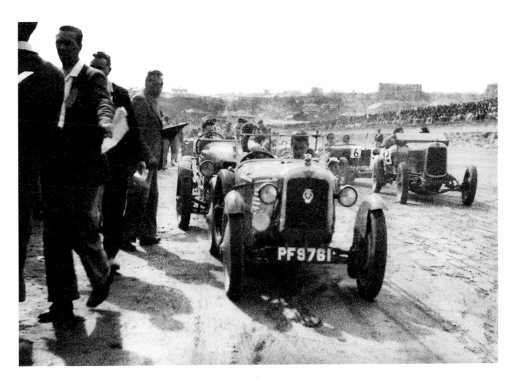

Cars racing on the Strand drew great crowds.

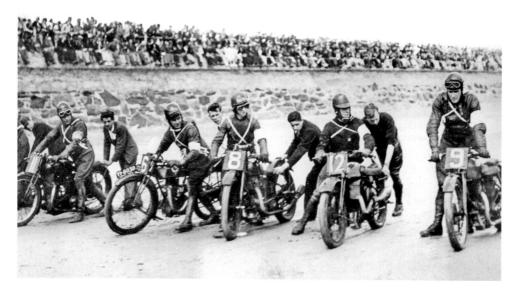

Motorcycle racing was also staged on the Strand. (Andy Taylor)

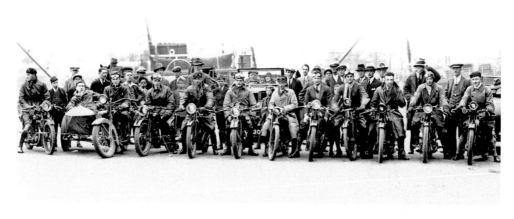

Members of Tramore Motorcycle Club lined up on Waterford Quay. (Marion Cantwell)

3

SHIPWRECKS

In the days of sailing ships, when vessels depended on the wind and tide, Tramore Bay was notoriously dangerous for shipping, and storms frequently resulted in tragedies, the worst of which was on 30 January 1816, when the sailing-ship *Seahorse* went down with the loss of 363 lives, comprising men, women and children. Just twenty-eight survived. The ship was bringing soldiers and their families home from arduous foreign duty during the Napoleonic Wars and was headed for Cork when a terrible storm caused it to lose its foremast and have its mainsail cut to ribbons. It was helpless before the gales and all Captain Gibbs could do was anchor in Tramore Bay. But the storm became so fierce that the anchors dragged and the ship ran aground with the mountainous waves pounding her to pieces. People were washed overboard in large numbers and very little could be done to save them. The ship's lifeboats had all been lost and it was impossible to launch lifeboats from the shore because of the enormous waves. Many of the few who were saved were dragged out of the sea by Tramore residents, at the risk of their own lives.

It was largely because of this calamitous accident that it was eventually decided to construct the two towers at Brownstown Head and three with the Metal Man at Newtown Head. Ships frequently confused Tramore Bay with the nearby entrance to Waterford Harbour and these were intended to help them distinguish one from the other – but sadly wrecks continued, probably at an average rate of two a year during the nineteenth century.

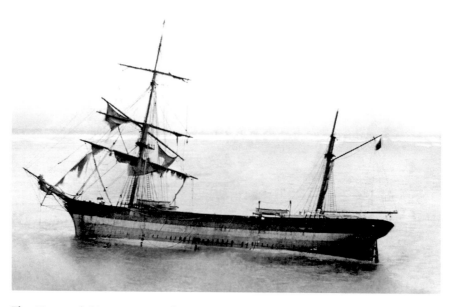

The *Monmouthshire* ran aground 200 yards from the pier on 12 January 1894 and, thanks to mighty work by the coastguards, all of the crew of twenty-one were saved. (Jimmy Fitzgibbon, Cavanagh Collection)

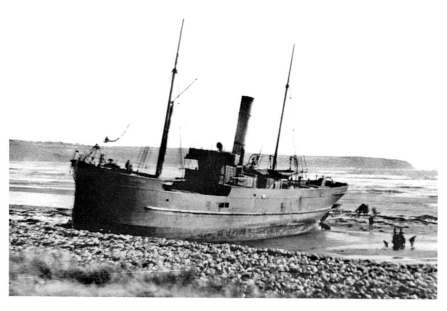

The steamship *Scott Harley* was beached the same year on 17 November. Despite the towers marking Tramore Bay, the ship's captain thought he was entering Waterford Harbour. All the crew of twelve were saved by the local lifeboat. The ship was carrying coal and this was sold off as salvage at 5s per load. The locals came in large numbers with horses and carts and endeavoured to get as much as possible; so much so that the load price went up to 6s the following day. (Jimmy Fitzgibbon, Cavanagh Collection)

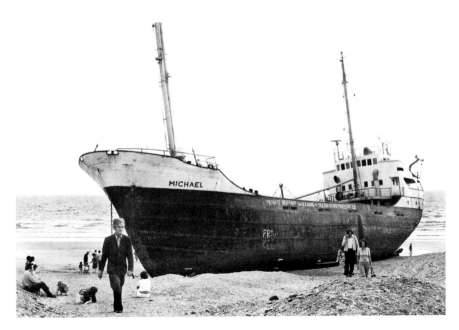

A much more recent wreck was the coaster *Michael* that went aground due to engine failure on 16 January 1975 when there was a force 11 gale blowing. There were no fatalities. It was found impossible to refloat her and eventually she was largely cut up for scrap with the rest lying buried in the sand. (Mike Hackett)

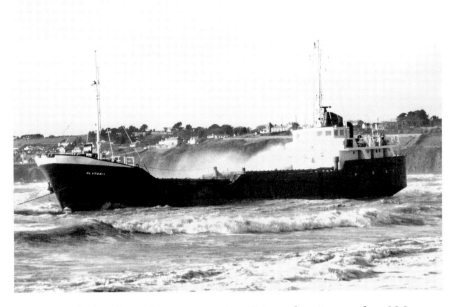

Though much abated, wrecks were to continue into modern times and on 13 January 1989 another coaster *Gladonia* grounded on the beach and the crew of four was lifted off by helicopter. Another case of one bay being mistaken for the adjoining one. (Andy Taylor)

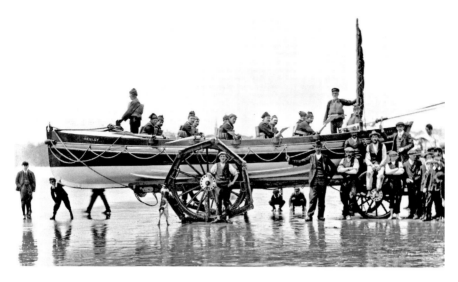

Tramore got its first lifeboat in 1858. It was a rowing boat that took six oarsmen. Other lifeboats came and went after that until the RNLI supplied Tramore with this bigger ten-oared boat called *Henley*. (National Library of Ireland)

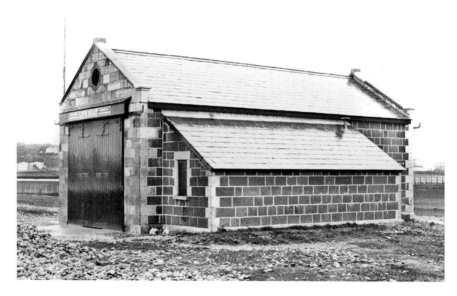

The lifeboat station at Riverstown – it was moved there from the Back Strand when that location became untenable due to flooding. It was closed in 1924 and now belongs to the Moores, who also own the Ocean View Guest House next door. The RNLI have been in Tramore since 1858 but at some stage the rowing boat was replaced by the power-driven lifeboat moored at Dunmore East. However, after a serious canoeing accident in Tramore in 1963, it was decided that Tramore should get the first prototype inflatable lifeboat with outboard engine (*Zodiac*), which takes a crew of three. There are twenty-one RNLI volunteers in Tramore, all with pagers to get 999 calls. Their boathouse is at the pier and they operate from there. (Jimmy Fitzgibbon, Cavanagh Collection)

4

TRAMORE TRAIN

The arrival of the railway to Tramore in 1853 was a marvellous development and was largely responsible for the growth and development of Tramore. It came at a very early stage of train building in Ireland and gave Waterford city its first railway station. The city was to get two more stations some years later and this meant that people from inland places could come to Waterford by train, walk the mile from one station to the other and then take the fifteen-minute train journey to glorious Tramore.

For those who have read *The 5-Minute Bell*, chronicling the 107-year history of this famous train, we will be brief. Suffice to say that the train served Tramore very well and was widely loved by its patrons. The idea to build this short line and the financing thereof was all local – a great achievement in times of considerable poverty and famine. It was a private company, efficiently and profitably run by a local board of directors. It provided a terrific service and never made a loss. However in 1925, even though it was the only railway not physically connected to the rest of the rail systems, it became amalgamated into a group consisting of all the twenty-six privately owned railway companies in the Irish Free State. This rail consortium, Great Southern Railways, was to eventually become a state-owned transport operation, managed entirely from Dublin.

By 1959 the Tramore train was carrying 424,000 passengers annually. This was a whopping number and did not include the many children who sneaked onto the train without paying! And it must be born in mind that the bulk of the heavy traffic was confined to the fine-weather periods. Instead of taking steps to rectify the train's relatively minor losses, CIÉ closed it down on 31 January 1960 and busses were substituted at much dearer prices. If the bus ticket price had been implemented in respect of the train, the train's losses would have been more than wiped out.

As was said in *The 5-Minute Bell*, they took away the train that Waterford and Tramore people cherished and charged more for the replacement busses that were hated.

Since the amalgamation of both city and county local authorities, Tramore has virtually become a suburb of Waterford city. It is effectively the city's major relaxation area and this is expected to result in even greater development of Tramore. The prom has already been substantially improved; the new access road to the Strand greatly helps the flow of traffic during the summer and a public park with play areas is the subject of major investment.

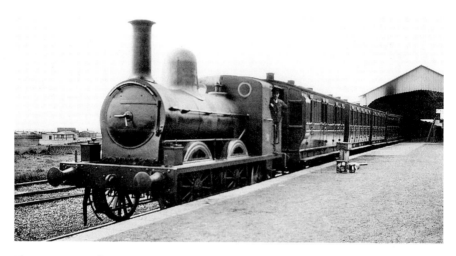

The train steamed-up and ready to leave Tramore station. (Waterford County Museum)

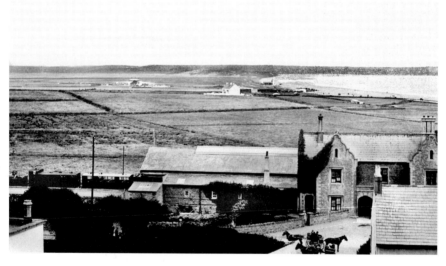

Even though no longer in use, Tramore station has a preservation order and is still intact. All Tramore were delighted when the City and County Council had the great foresight to acquire it recently and they are drawing up plans to utilise the building and its environs for civic purposes.

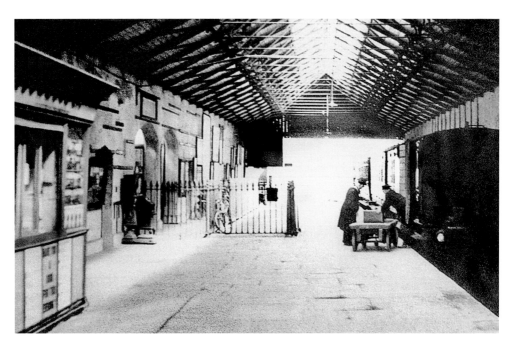

The Tramore train also carried parcels and goods – and even live animals when required. Shops in Waterford regularly used the train to deliver parcels to customers in Tramore.

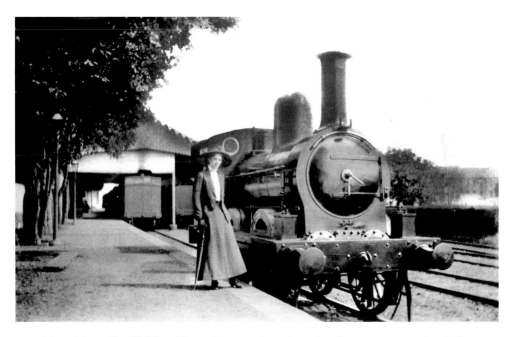

Nurse Mary Alice Walsh at Manor Street station prior to her departure on nursing duties in Malta in 1915. She was highly acclaimed for her nursing expertise but contracted a rare disease and died not long afterwards.

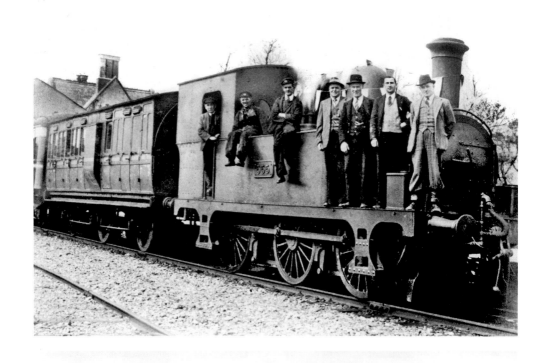

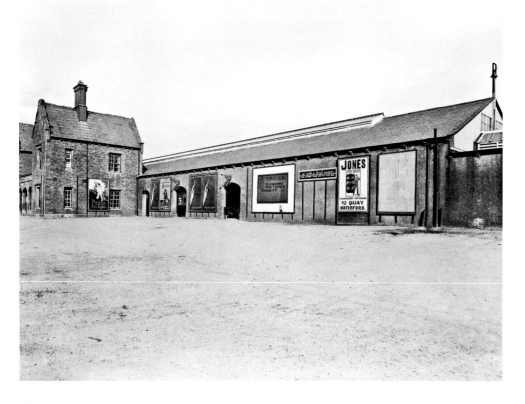

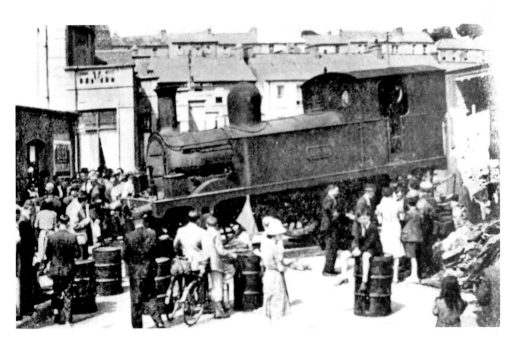

Everybody who reminisces about the Tramore train is sure to mention the famous derailment at 11.15 p.m. on 14 August 1947, when the brakes on locomotive 560 failed and it continued through the station (but minus its carriages), through the wall and onto Strand Road. Miraculously nobody was killed or even hurt, despite it being Race Week when Strand Road is usually thronged. This was due to a fortunate mistake when the five-minute bell was wrung a bit too early and the crowds had obediently left Strand Road and gone to the station to be sure not to miss the last train. It took less than two days to get No. 560 up again on the tracks where it would soon be back working normally. (Andy Taylor)

Opposite top: Some of the staff proudly posing for a celebratory picture in 1953 when the Tramore train was 100 years old. From left to right: C. Murphy, Tony Griffin, P. Daniels, T. Dwyer, J. Hayes, T. Colbert, E. Power.

Bottom: Tramore station in April 1929 – on the pole rising from the station shed's gable end is the five-minute bell, which was wrung to warn would-be passengers of the train's imminent departure. (National Library of Ireland)

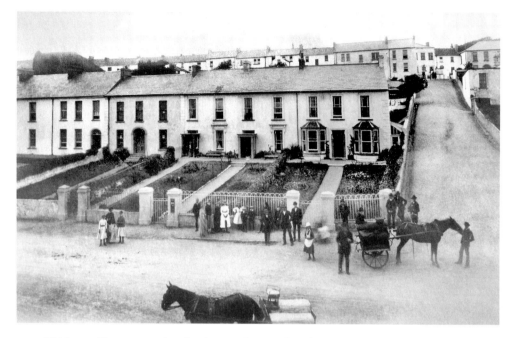

Waiting at Tramore station for the train's arrival with Train Hill rising steeply at the right. The horses are harnessed to jaunting cars, which acted as taxis. A post box can be clearly seen on the gate pillar of the second house. Although they are now painted green, they are inherited from a former era – this one has a crown and 'ER VII' embossed on it. (Andy Taylor)

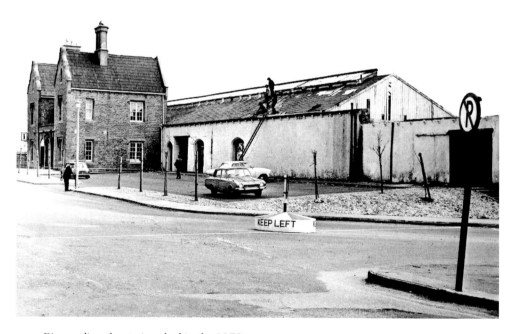

Dismantling the station shed in the 1970s.

5

BUSINESS IN TRAMORE TOWN

There were many small, individual shops in Tramore during the period covered by this book. Businesses were almost exclusively owned by local families, who traded in their own specialities, be they butchers, bakers, grocers, drapers, newsagents, pharmacists, hardware merchants or whatever. Supermarkets had yet to arrive.

The close proximity of Waterford to Tramore meant that with improved transport links locals could rely on the city as a major retail destination. Purchases such as furniture, white goods and sports equipment immediately come to mind. While Tramore now has fewer shops, many of the chain stores found in most towns nowadays can cater for a lot of what the cities have to offer.

However, let's start our reminiscences of Tramore retail through the years with the street traders.

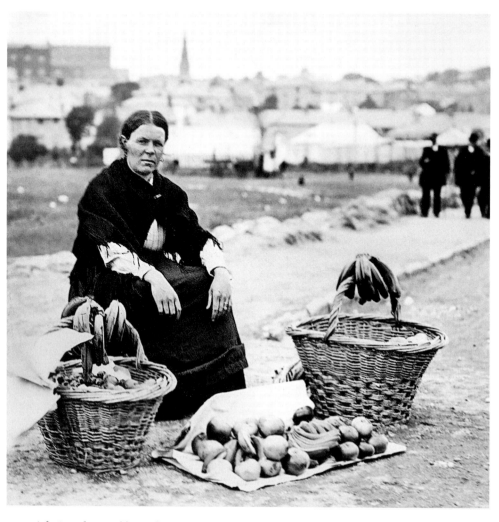

A fruit and vegetable vendor on Strand Road.

Right: This lovely colleen may well also be selling fruit.

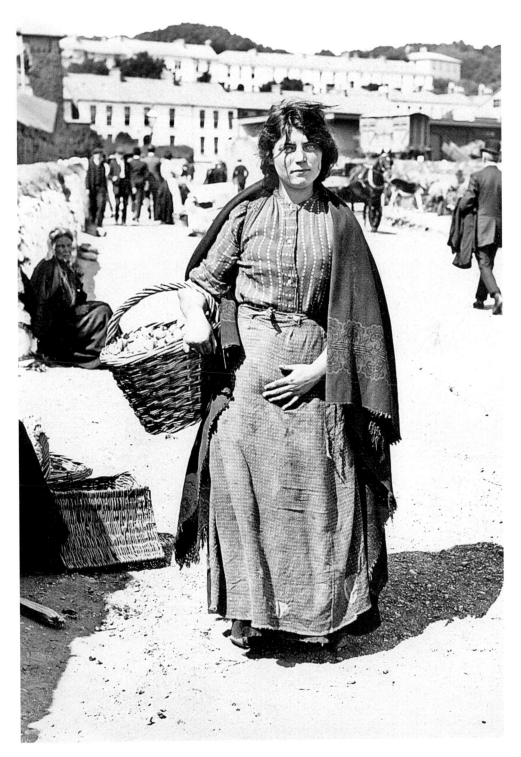

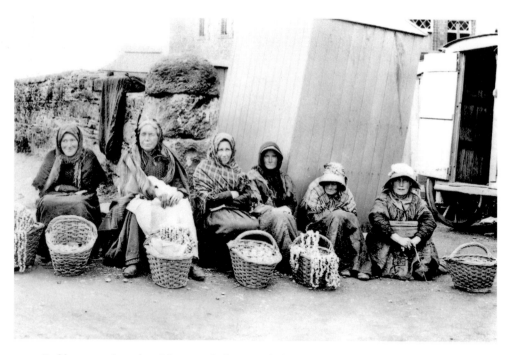

Cockles, mussels and necklaces made from seashells are among these ladies' wares.

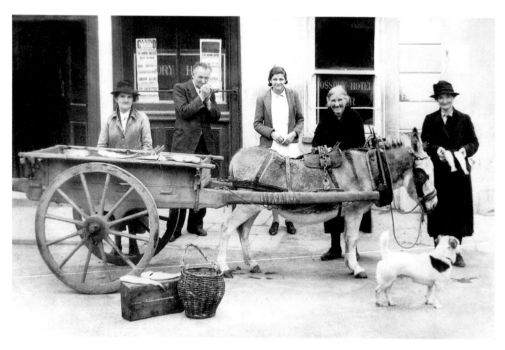

Fish being sold outside the Ossory Hotel at The Cross in 1945. In the window can be seen posters for Tramore's two cinemas at that time – the Rex and the Casino. (Andy Taylor)

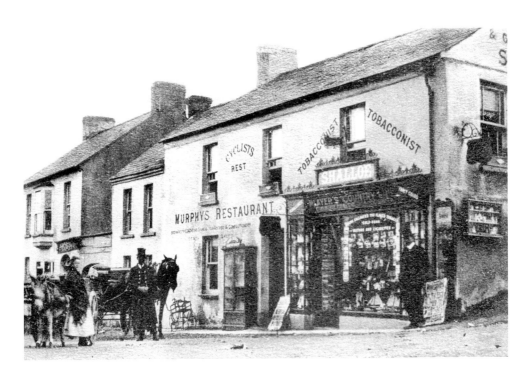

This photo dates back to 1895 and shows Shalloe's tobacconists beside Murphy's restaurant. Around Waterford Shalloes is pronounced 'Shallows' whereas in other parts it is pronounced 'Shalloos'. (Andy Taylor)

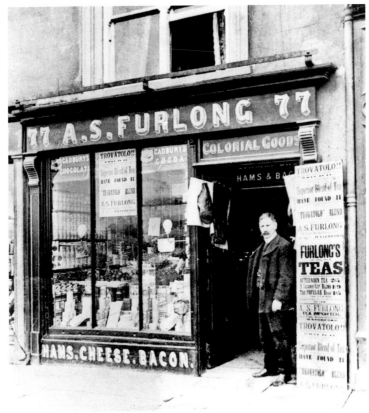

Furlong's grocery.

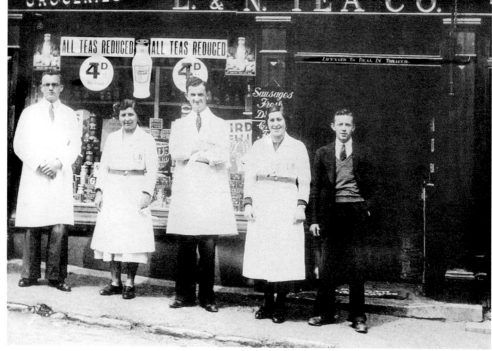

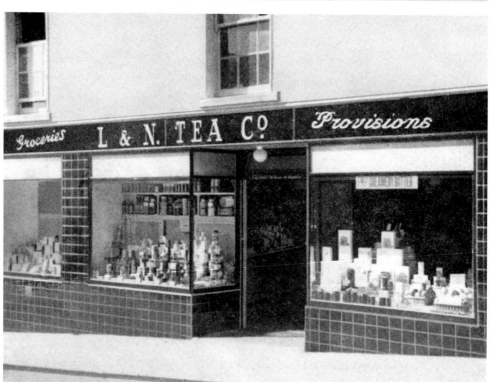

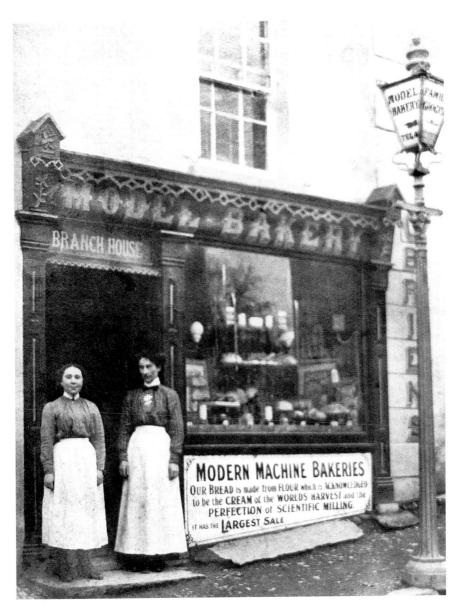

O'Brien's Model Bakery – many years later it was to combine with others as Gold Crust. (Andy Taylor)

Opposite top: The London & Newcastle Tea Company was always known as the L&N, even after 1995 when it became SuperValu. This photo of the L&N on the left of Main Street (going down the hill) was taken in 1935 and includes Charlie Matthews, who was the manager, with P. O'Connor, E. Fitzgerald and Martin Kirby. Owned by the Torrie family, this was the first L&N branch to come to Tramore. (Andy Taylor)

Bottom: A revamped larger L&N on the opposite of Main Street beginning to take on the mantle of an early supermarket.

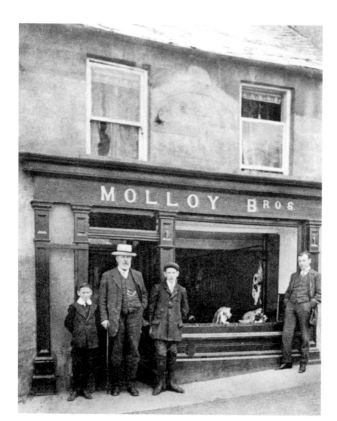

Molloy's butcher shop.
(Andy Taylor)

Cahill's drapery, cigarette, newspaper and fancy goods shop at The Cross about 1910. The man with the moustache in the centre is Edward J. Cahill. The chap with the silver-buttoned waistcoat is quite possibly the porter from the Great Hotel. The girl seated with dark coat is Gretta Cahill, who later became Mrs David Kenneally when she married the son of Mrs Mary Jo Kenneally, who owned the shop two doors uphill. In turn, Gretta was to become mother of David Kenneally Jr, who kindly supplied this photo. Her pal in the white dress is Kitty Donnelly, who lived at the top of Main Street. (David Kenneally)

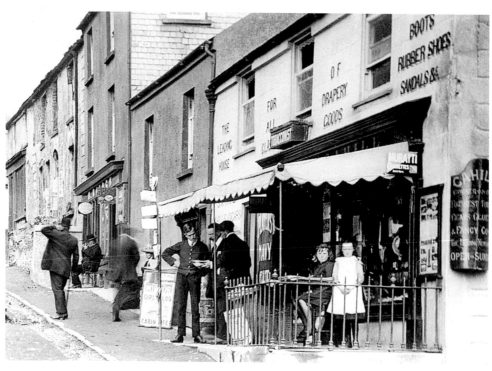

'Limerick Bill' was one of Tramore's popular characters during the 1940s. He spoke fluent Irish and is reputed to have greeted tourists in the native tongue. Bill figures in many stories, including the time during the Second World War, when he met local men of considerable standing who were coming back about 6 a.m. after a night on air-raid patrol and he greeted them with, 'Did the fleas get you out?' He was adept at knitting and used to sit outside the Atlantic ballroom knitting away while chatting to passers-by. (Andy Taylor)

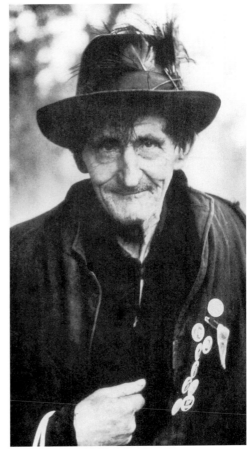

Andy Butler, better known as Rooney, was also a lovable inoffensive character and a familiar sight around Tramore Golf Club where he was an excellent caddy, frequently being called upon to carry the clubs for the great Christy O'Connor Senior when he came to Tramore. Rooney was a superb golfer himself and willingly passed on his knowledge of the game to both adult and junior members. There are long-standing members who can happily recall Rooney strolling along the 12th fairway with a tame crow hopping behind. (Andy Taylor)

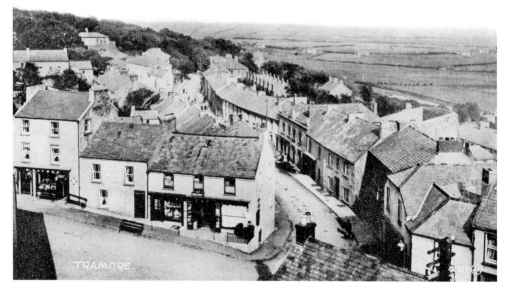

This photo (*c.* 1900) of The Cross was probably taken from the top storey of the Great/ Grand Hotel. (Norma Boyle)

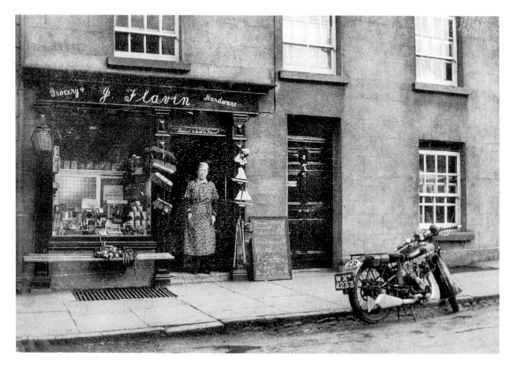

Flavin's hardware and grocery store in Queen Street, *c.* 1930. (Andy Taylor)

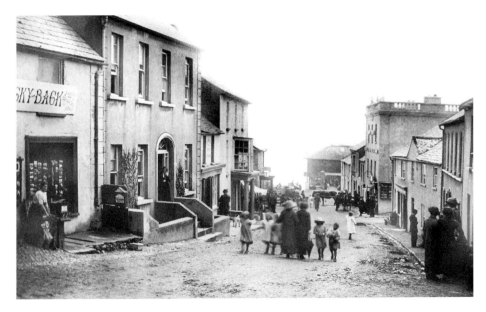

Sticky-Back Power's famous photography shop on the left of Strand Street. Few people had their own cameras in those days and depended largely on professional photographers to capture family events. Sticky-Back possessed a fine tenor voice, earning him the second nickname of Tenor. (Andy Taylor)

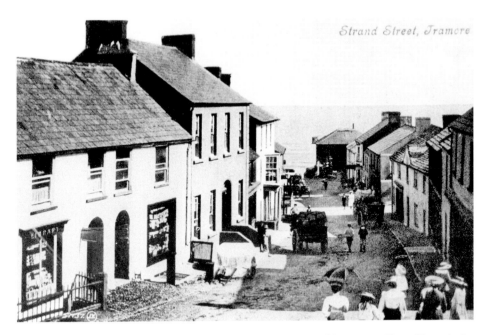

An earlier postcard of the same view, probably before Sticky-Back's time. Kickham House is the imposing building with steps up to the hall-door with Corbett's, later the Avondale bar, later still the Sea Horse and now Banyon next door to that. Tramore Library was then the first on the left – perhaps there are books displayed in the window.

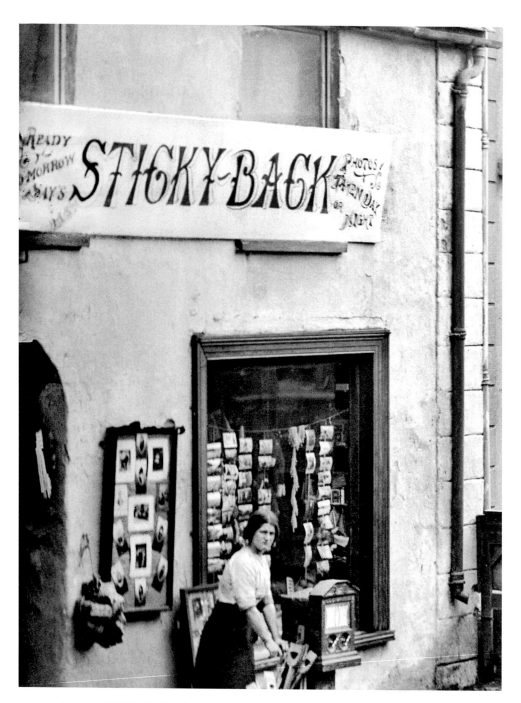

A close-up of Sticky-Back's shop.

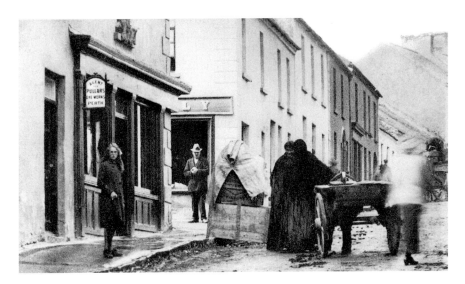

At the corner where Market Street meets Main Street was Hally's butcher, later to be replaced by the Rex cinema and now Cahill's.

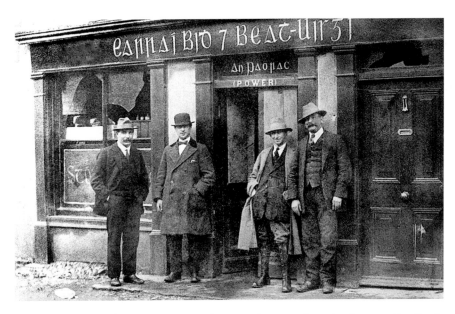

Power's pub in Market Street was in the gap where another street serves the Garda barracks, pedestrian access to SuperValu, parking and the Boxing Club. It was removed when the street was created. It was well known to be a republican pub and in the middle of the night of the Pickardstown ambush (see chapter 12) British soldiers fired shots at the pub as a reprisal. This picture was taken afterwards and broken windows and bullet holes can be seen clearly. One shot ricocheted off the pub, was deflected across the street and entered an upstairs window of Bohill's house, where it embedded itself in a book beside the bed of Jackie Bohill who no doubt was then wide awake and thankful that he had not been hit. (Andy Taylor)

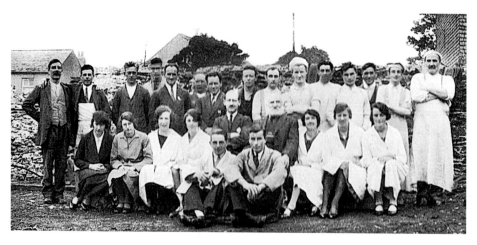

Lodge's bakery staff in 1929. Lodge's general grocery was on Summerhill (at the junction with Old Waterford Road) and was sold to Darrers in the 1980s. In the latter part of the 1800s John Harte-Lodge Senior came from Kilkenny to open his general store in Summerhill. He had three children, the youngest of whom was John Joseph Harte-Lodge, generally known as Jack, and just the 'H' of the double-barrelled name was retained. Jack took over the business from his father and was a highly successful businessman. He is seated in the centre of the photo, with arms folded, and his father is the bearded man to the right of him. Lodges was the first shop in Tramore to have a fridge. (Mary Jennings)

Upper Main Street with the early Cunningham shop clearly distinguishable on the right. Michael and Annie Cunningham came to Tramore in 1946 and opened their fish and chip business in 1948. They soon became famous for their quality fare and their sons Michael and Padraig continued that proud tradition until 2007 when they sold the business to Italians who later sold to Doolys. (Andy Taylor)

6

PUBS, RESTAURANTS AND LEISURE

In the days of far fewer cars on the roads, visitors tended to stay for a week or more to enjoy their holidays so Tramore had a great many hotels, many of them small. Santa Ponsa was unheard of and many couples spent their honeymoons in Tramore. In this chapter we are reminded of these hotels and also of some of Tramore's eighteen public houses.

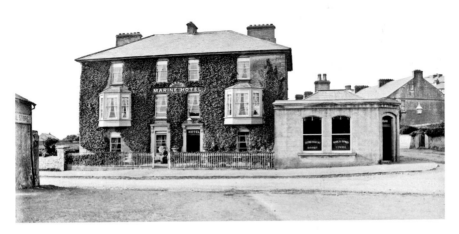

The Weston Marine Hotel was closest to the raiway station. It later became The Deluxe and is now The Sands Hotel.

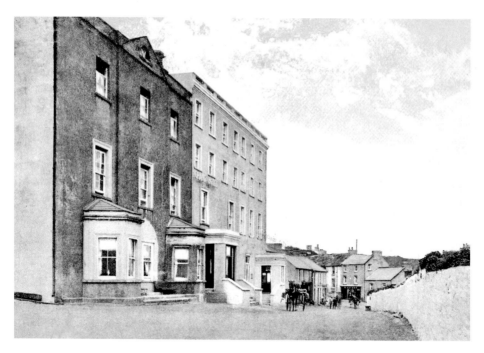

The Great Hotel, which was built by Bartholomew Rivers after he came to Tramore in 1778. It was extended many times and changed hands frequently. (Waterford County Museum)

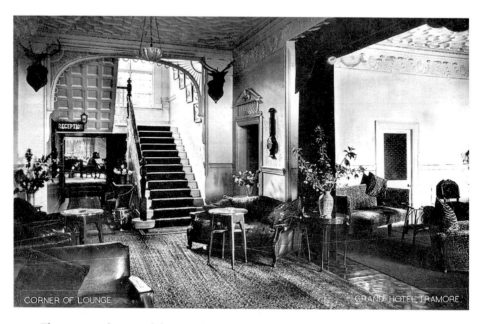

The entrance lounge of the Grand Hotel as it was many years ago. It is said that in 1915 the dress code for dinner was white tie and tails – no wonder the name was changed to Grand. (Norma Boyle)

This hotel was initially called Kelly's, because it was built in the early 1920s by Waterfordian John Kelly who also had Ireland's first motor garage (W.F. Peare Ltd, later Kelly's, Catherine Street, Waterford, established in 1900). The hotel became the Majestic in the 1940s when it was sold to the Breen family (who had other hotels and many cinemas). The hotel's hard tennis court was between the hotel and the railway tracks and one of the garages in this photo (taken 1933) was converted for badminton. (© Historic England)

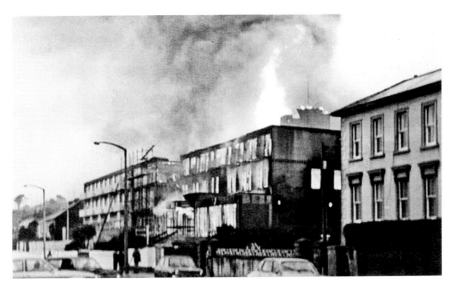

The hotel was struck by fire in 1979. By then another wing containing self-catering apartments and an indoor pool had been added and this section was not affected by the fire. In 1981 what was left of the Majestic was purchased by Tramore Fáilte (see chapter 9), who carried out redevelopment work and repairs to the burnt-out shell. It was reopened in 1983 and in 1987 sold to the current owners, Annette and Danny Devine who have further developed it into a four-star hotel.

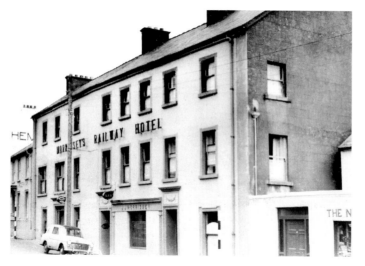

Morrissey's Railway Hotel – now O'Shea's Hotel. In its early plans the railway line was to run further into the town and terminate here. If that initial plan had been followed, this would have been the site of the Tramore railway station. (Norma Boyle)

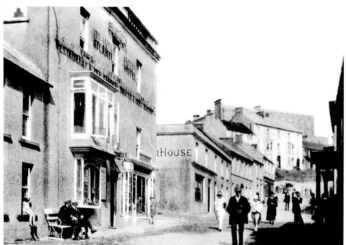

By the time this photo was taken, Shalloes had bought out Murphy's Restaurant next door and had built a three-storey hotel on the site previously occupied by a small shop and restaurant (see page 59) at the corner of Gallwey's Hill. The Corner House Bar was on the opposite corner and was owned and managed by Kitty Brennan.

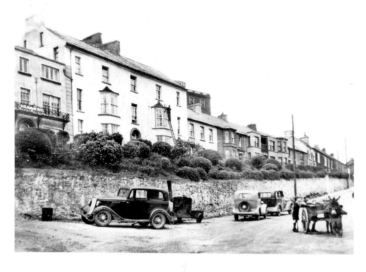

The Boolabawn Hotel was on The Terrace but is long gone as hotel. The Baby Ford seems to have been popular in Tramore at the time.

The once fine Tramore Hotel on Strand Street – now, alas, no longer so.

Corbett's bar on Strand Street in 1890 where food was served – unusual for those times. Its name was later changed to the Avondale and then to the Sea Horse Tavern and Banyon. (Andy Taylor)

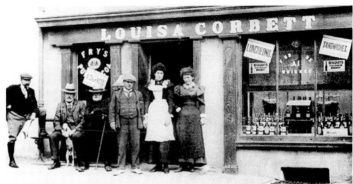

A side view of the Hibernian Hotel, which was originally called O'Neill's Hotel, then Quigley's, then Fry's before becoming the Hibernian in the 1920s when it was purchased by the Breen family, who also operated a garage beside the hotel. There was a hand-operated petrol pump at the kerb which had two glass bottles through which the petrol flowed – so you could see what you were getting. (Waterford County Museum)

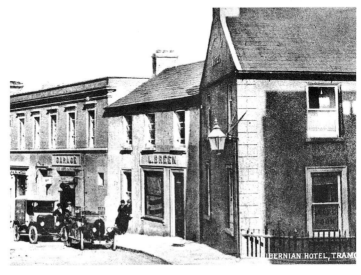

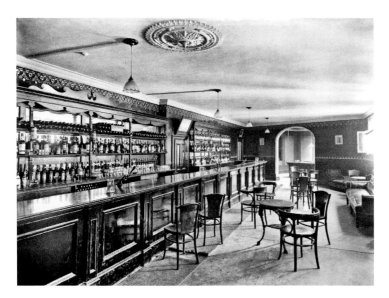

The bar in the Hibernian Hotel. (National Library of Ireland)

The Atlantic Hotel on Marine Terrace faces Railway Square with the ball alley right behind. The hotel is currently being used by the Government to temporarily house asylum seekers.

Children pose on the front lawn of the Atlantic Hotel during the 1950s with the railway station across the square behind them. (Jim Hally)

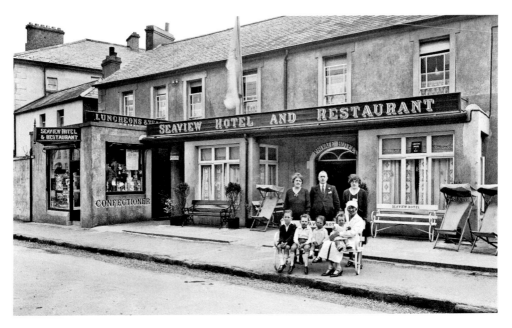

The Seaview Hotel on Turkey Road was owned by the Fitzgerald family. It changed hands and is now amalgamated with the Sands Hotel.

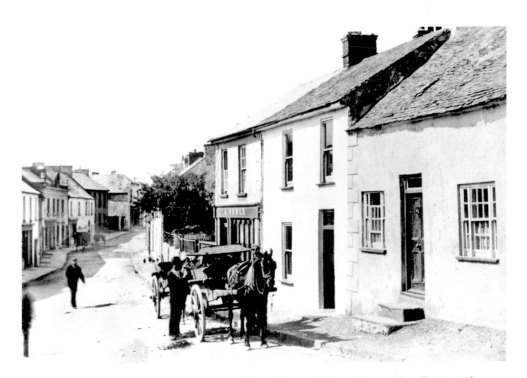

Parking on Queen Street in 1896 outside Geoff Power's bar – later to be affectionately known at Martha's. (Andy Taylor)

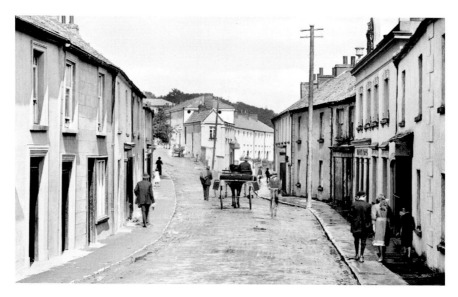

Queen Street with the Victoria bar ('the Vic') on the right. It was previously known as Quade's Victoria Hotel.

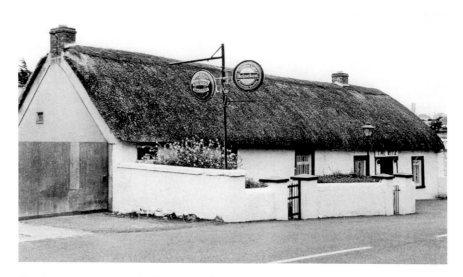

The Ritz on Newtown Road is the only thatched pub left in Tramore. This building originally comprised three cottages and, when the Reynolds family took ownership of the property in late 1800s, two cottages were amalgamated to form a pub. When William Reynolds died, his wife Mary continued to run the pub. Her son, Willie Junior, worked for a company involved in the transatlantic cable running between Newfoundland and Ireland and that may be why his nickname was 'Canada'. He then took over the pub from his mother. But why call a thatched pub The Ritz? Local folklore has it that Reynolds perpetually owed money and was continually having to contend with the writs being served on him by his creditors – so much so that he called the pub The Ritz. It may not be true but no other explanation has been found. (Andy Taylor)

7

STREETS, ROADS AND RESIDENCES

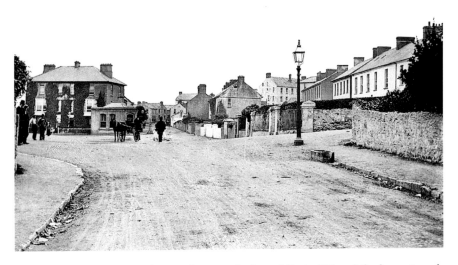

Railway Square – note the fine gas lamp at the foot of Train Hill and the horse trough beside it. Around the corner, on Train Hill wall, there is an old tap with water for humans. Embossed on the cast-iron basin, which was manufactured in Kilmallock, is 'Keep Pavements Dry' but there are no pavements on Train Hill.

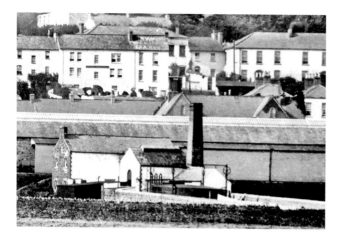

Tramore made its own gas and the gasworks with its tall chimney is pictured here. Coal to feed its furnace was delivered by train to the railway station right beside it. Tramore houses got piped gas in 1865. (Andy Taylor)

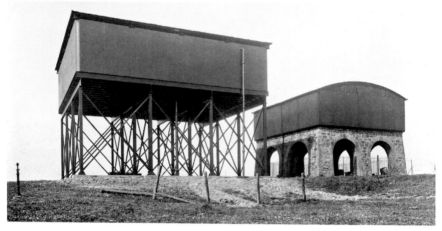

Above: Tramore got its water from these tanks, located behind the convent schools in a field that to this day is referred to as the tank field. The tanks were rendered obsolete when other water sources came into use. The Council then converted the use of tank field into offices, meeting rooms and parking spaces for Council vehicles. Following the amalgamation of the County and City Councils, it was no longer required by the Council and is now used to house a business called nearForm, started by a bright young Tramore local. (National Library of Ireland)

Opposite top: Here is Pickardstown junction where three roads meet and where a famous ambush took place during the War of Independence. The approach from Waterford is along 'the new road' and this is joined by two roads at the left: the 'old road', which feeds in from the north, and the Ballinattin Road (also called Shrine Road), which is a twisty scenic road to Dunmore East and other places. There were no houses or petrol stations on the way into Tramore then. (National Library of Ireland)

Centre: Built in 1807, Patrick Street is in the centre of town. It is not named after Ireland's patron saint but after local property owner Patrick Power. (Thomas Jones)

Bottom: Turkey Road, with the ivy-clad Lyon Terrace looking good and deliveries being made by the horse-drawn bread van. (Andy Taylor)

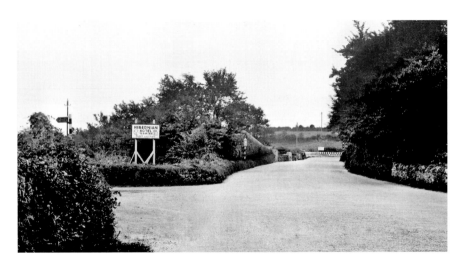

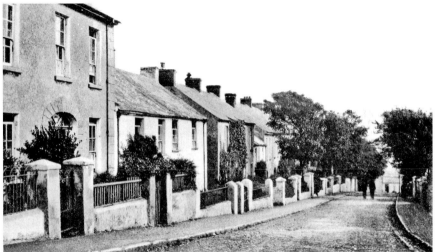

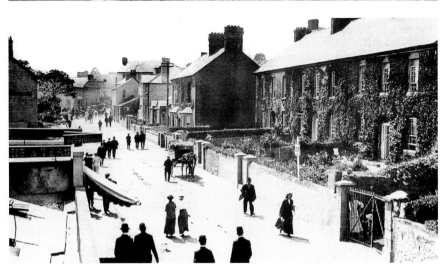

This very old photo of Strand Street from the Cavanagh Collection was taken before the era of tarmacadam. Some of The Terrace houses look quite new on the right. (Jimmy Fitzgibbon, Cavanagh Collection)

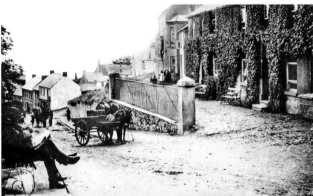

By the time a photographer again captured The Terrace, a good crop of ivy adorned it.

P.J. Power was MP for East Waterford. Those were the days when Ireland was part of the United Kingdom and our representatives travelled to London to attend Parliament at Westminster. His home in Tramore was Newtown House. (National Library of Ireland)

Below left: Atlantic Terrace is off Church Road and consists of five houses. It is believed they may have been built in the 1800s to house members of the British Army and there were communicating doors between every house – these have since been bricked up. They may have changed from army to coastguard use but by the early 1900s they passed into private ownership. The wide path facilitated horse-drawn coaches which could continue around the end of the terrace to stables at the back.

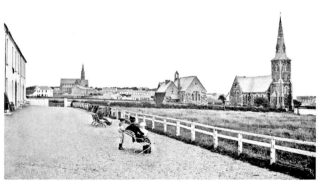

8

PLACES OF WORSHIP

Let's start with the Roman Catholic church. In the sixteenth century, the townland of Tramore comprised only ten people. There were more people living in nearby Drumcannon and therefore the parish church was there (if you take the old road to Waterford and go up a laneway you will find traces there). It was a very old church and soon went into ruins and, between that and the rigours of the Penal Laws, a Mass House came to be used at Pickardstown, not far away. Bartholomew Rivers was a Catholic and, because his aim was the development of Tramore village, in 1784 he built a thatched chapel, which was located where the graveyard is situated in front of the present church.

By 1853 the small thatched chapel was inadequate for the increased population and visitor numbers and in poor condition. Father Cantwell had been parish priest since 1830 and in 1854 he formed a committee to work on the project of building a bigger church. A year later they got the present site from Lord Doneraile for a nominal rent. The architect selected was the renowned J.J. McCarthy and it is said that, when he asked the priest what kind of design he wanted, Fr Cantwell pointed to the recently constructed Protestant church and said, 'I want you to bate that'. McCarthy certainly lived up to these instructions and delivered a most impressive cathedral-like edifice.

The entire cost of Holy Cross church must have been in excess of £18,000, which was a tremendous sum in famine-torn Ireland. Undeterred, the committee got to work and fundraising projects commenced. The nice story goes that the first donation came from the Protestant rector. Concerts, fairs and bazaars were held and subscriptions came from the locals and from their relatives in America.

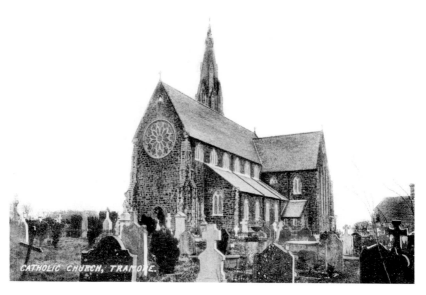

CATHOLIC CHURCH, TRAMORE.

Holy Cross church is a most commanding building which is visible for miles around. James Ryan was the building contractor and the foundation stone was laid on 14 September 1856. Except for the spire, the church was completed in less than four years and it was duly opened on 29 July 1860. Construction of the spire commenced ten years later in September 1870 and, despite having to cease work for safety reasons during the winter, the job was finished by September 1871. (Padraig Cunningham)

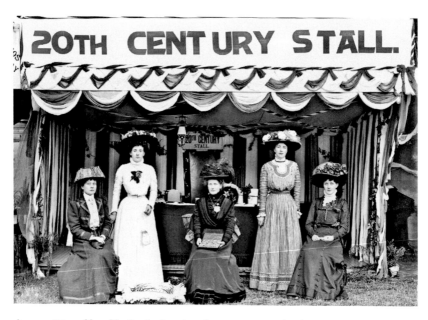

20TH CENTURY STALL.

A committee of local ladies had undertaken to organise fundraising events and on 1 March 1872 a major bazaar was staged in Tramore. Maybe these good ladies were selling articles that they anticipated would increase in value in the coming century.

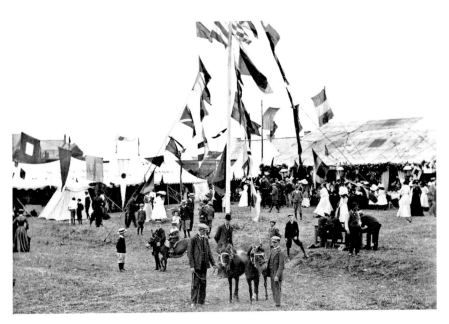

Even though Tramore was then only a small place, people came from Waterford on the train to see what all the excitement was about. Could that be a tricolour flying in 1872?

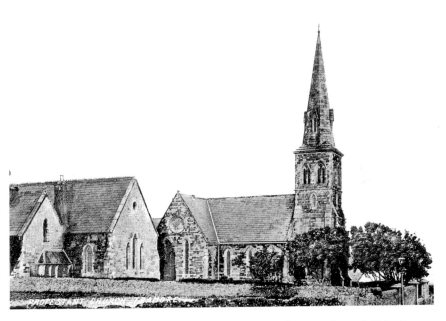

Christ Church (C of I) gave the name to Church Road, where it is located. This site was also provided by Lord Doneraile. However, it was not the original church on this site. Nearby, a smaller church was consecrated in 1809 when Revd John Cooke was rector. But when Revd Edward Dalton took over from Revd Cooke (who lived to be 100) he decided a new, larger church was required. Built beside the first church, the existing church was opened for worship in August 1850. (Waterford County Museum)

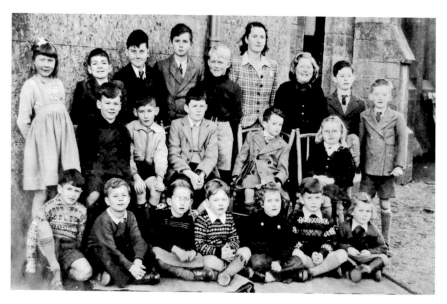

The C of I National School is to the left of the church in the previous picture on page 83. The teacher, Miss Thompson, is pictured here with her young pupils of 1948/49. From left to right, front row: Max Nicholson, Winfried Fetke, Jennifer Clarke, Trevor Matthews, Jennifer Jacob, Garry Nicholson, Artrun Fetke. Second row: Philip Hamilton, Desmond Greer, George Bolster, Roger Elms, Jane Doupe. Back row: Hyadiss Glass, Dermot Charles, Dick Baldwin, Willie Bolster, Peter Stuart, Miss Thompson, Valerie Greer, Julian Walton, Cyril Clarke. (Julian Walton)

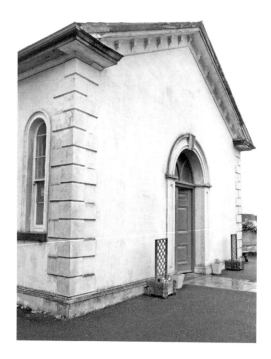

The Friends' Meeting House on Upper Branch Road. The Religious Society of Friends (known generally as Quakers) have been in Ireland since 1654. Instead of a church, they have a meeting house for Sunday worship and the Tramore branch got theirs in 1870, when it was constructed with the help of Edward Jacob. The Quaker ethos includes philanthropy and many relief measures were carried out by them during the Great Famine. They are also renowned for their entrepreneurship and were responsible for setting up many thriving businesses in Ireland. Their numbers are fewer now and the Meeting House has been leased out to the Brothers of Charity to help those with intellectual disability.

9

AMUSEMENTS

Tramore is well noted for its amusements located along Strand Road. In 1895 the entrepreneurial Martin J. Murphy decided that Tramore needed greater entertainment for visitors and the carnival operators Tofts accepted his invitation to come to the resort. A Mr Beach was part of their staff and his daughter was married to Bill Piper. This began the legendary Piper family association with Tramore.

In the early 1920s Wilf Iddon of Liverpool used to bring his fairground attractions to the Isle of Man until somebody advised him that there was a greater opportunity in Tramore. And so he too came and never left. His fairground business lives on through the Dooly and other families, descended from Wilf.

As the years rolled on, additional amusement caterers came to Tramore and those already there solidified their presence. In 1966 Bord Fáilte set up a company called Tramore Fáilte with the stated objective of developing Tramore into a major resort. Michael Cusack was the first manager and in 1969 Jim Tuohy was hired from Butlins in Mosney, County Meath, as general manager, reporting to a board of directors. A plan was put in place with fresh ideas for new amenities that would be of particular interest to families. As a result of its achievements, Tramore Fáilte was given the first Endeavour Award in 1972.

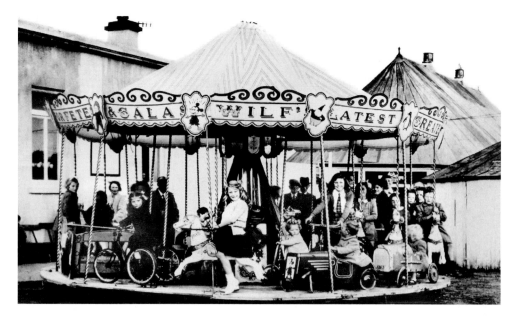

Wilf's hobby horses, cars and tricycles pulled a full load of children who were obviously enjoying themselves. This is fairly typical of the earlier kind of merry-go-round and probably would hardly appeal to modern sophisticated children reared on television and looking for excitement. (Andy Taylor)

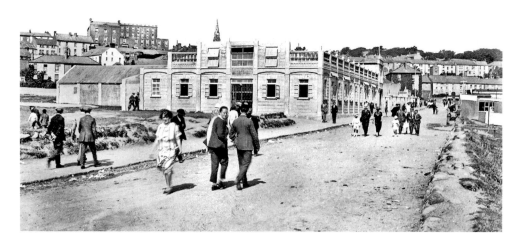

Bill Piper died young and his wife had to take over the business. Being a member of the Beach family, the fairground tradition was in her blood and she initiated several developments, including building the Atlantic Ballroom which was billed as the largest ballroom in the south of Ireland. As the years passed, various people owned the Atlantic and it was a busy place during the summer. At weekends there were two sessions – the first ending at 11.30 p.m. and the second ending at 3 a.m., when a special train was laid on to bring the late-night dancers back to Waterford.

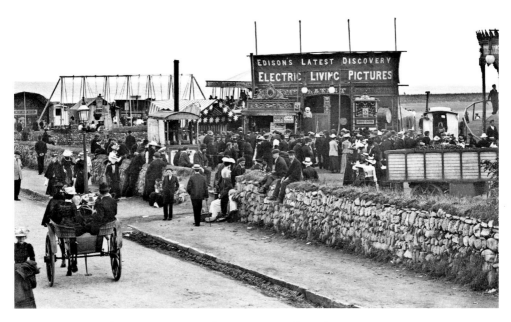

Introducing silent movies was another innovation of Beach Piper.

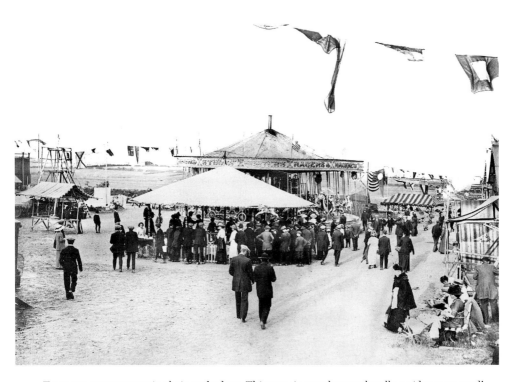

Tramore amusements in their early days. This area is now known locally as 'down around'.

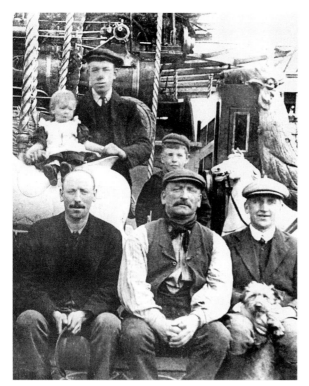

A Piper group photo with Bill Piper second from right and Johnny McGuirk on the extreme right – the latter was a great showman and in 1927, when at the World Fair in London, he bought the Nigerian Pavilion which he had dismantled and shipped to Tramore where it was to be used as a cinema (Casino), skating rink and dance hall (Silver Slipper). (Andy Taylor)

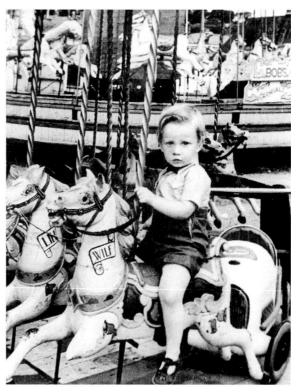

Wilf Iddon's grandson, Michael Dineen on his hobbyhorse (aptly named Wilf). (Andy Taylor)

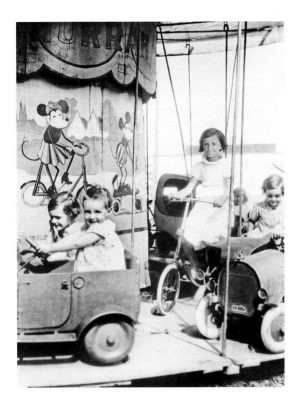

Anna Flood tries out the bike on this merry-go-round. (Anne Harpur)

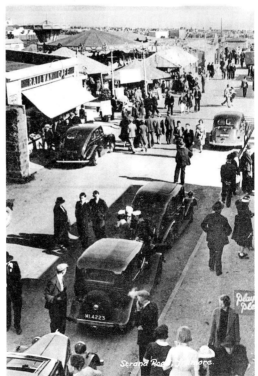

Busy Strand Road. The Railway Café (left) is now Misty's and opperated by Sally and Ray Herterich. (Waterford County Museum)

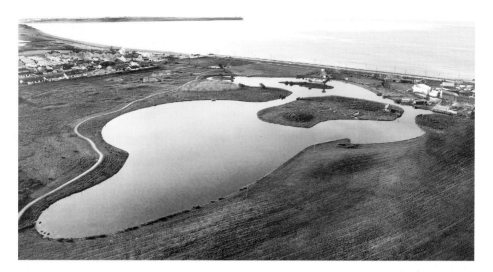

The largely waste area between the prom and the Lower Branch Road was purchased from John H. Lodge by Bord Fáilte and Tramore Fáilte set about the difficult job of draining the swampy areas and creating an attractive boating lake with its own islands. Peddle-craft, small rowing boats and canoes were purchased and were rented out for spins around the lake. This ground is now the property of Waterford City and County Council and has been earmarked for civic development. (Barry Sheerin)

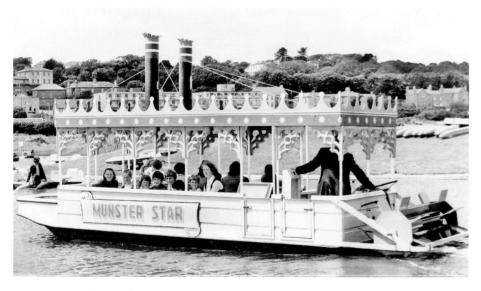

Pictured here is the imitation paddle steamer *Munster Star*, which was purchased in England by Tramore Fáilte and was launched onto the lake to bring youngsters and their minders on short 'voyages' around the newly formed lake. It was a lovely sight and Tramore Fáilte are to be congratulated on such imaginative initiatives. The name of the vessel was the result of a competition, which they ran in the two local newspapers, the *Munster Express* and the *Waterford News and Star*. (Jim Tuohy)

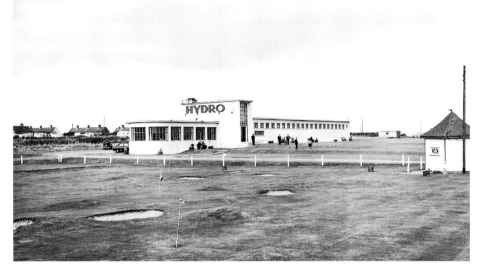

The Hydro with its seawater baths was opened in 1948. It was built for the Irish Tourist Board (forerunner of Bord Fáilte) by the Army Construction Corps. Unfortunately, the raw materials were inappropriate and, after a comparatively short life, the baths were closed and the adjoining restaurant was the only part that remained operating. Two very attractive pitch and putt courses are seen here and these attracted considerable interest. These are now also gone but there is a very fine course and practice range at Westown. Eventually, the Hydro was knocked and is likely to be used as the site for a major hotel development. (Mary Jennings)

Tramore Fáilte brought in the latest modern recreational equipment, including this miniature railway, which is still operating highly successfully. (Dick McCarthy)

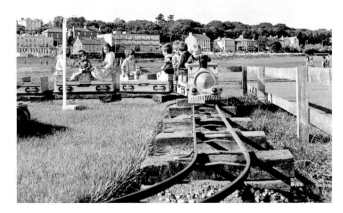

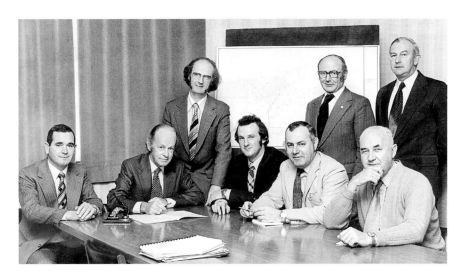

At the signing of the contract in 1978 to build thirty-five self-catering holiday villas to be constructed at Riverstown. Seated, from left to right are: Jim Tuohy (GM Tramore Fáilte), Paddy Breen (Chairman Tramore Fáilte), Seamus Neville (contractor), Bill Walsh (Director Tramore Fáilte), Jim Hally (Waterford County Engineer). Standing: Fred Quinn (architect), Finn Mongey (Accountant Tramore Fáilte) and Tom Barrett (Manager AIB Tramore). A new amusement park was also created by Tramore Fáilte and operators were invited to rent sites on which to put their attractions. (Jim Tuohy)

A major project was launched in 1991 to deliver a water-leisure facility, estimated to cost about £3 million. The European Union (EEC then) subscribed heavily and considerable sums were contributed by both Waterford County Council and Tramore Fáilte. The balance of £100,000 (about €125,000) was subscribed by the residents and the businesses of Tramore following a fundraising campaign by Tramore Town Commissioners. And so Splashworld came into being in 1994, complete with water slides and plunge pool. This is something that only a few resorts possess and it was achieved thanks to magnificent cooperation by all the parties concerned. (Barry Sheerin)

10

SPORT AND OTHER PASTIMES

We Irish love horses and in 1785 Bartholomew Rivers introduced horse racing to Tramore, initially on the beach and other locations. But in 1880 it was decided to move to the Back Strand where William Malcolmson had succeeded in completing the construction of an embankment in 1863 to cut off flooding and perhaps grow cotton for their mills. This engineering feat became known as Malcolmson's bank, and James and Alfred Budd of Sweet Briar Lodge decided to build a proper racecourse with viewing stand and all mod cons there. Further improvements were made in 1888 by Martin J. Murphy and his committee and so the Tramore August Racing Festival was born.

When cars were fewer, the train brought people to Tramore – at least until

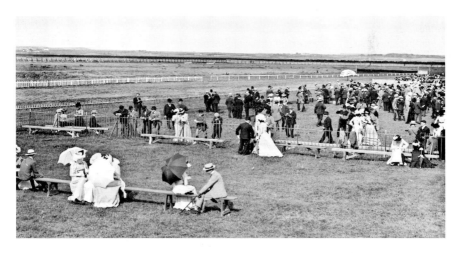

The racecourse at the Back Strand was certainly impressive and the ladies always brought out their finery when attending a race meeting. (National Library of Ireland)

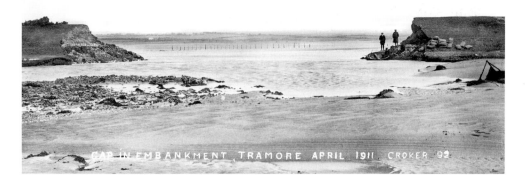

Proximity to the sea was a major problem and during 1911 there were two breaches of the embankment (in April and December) and the entire Back Strand became completely flooded. Fruitless efforts were made to mend the breech. Eventually they gave up and it was decided to move to higher ground at Graun, its current location. (Julian Walton)

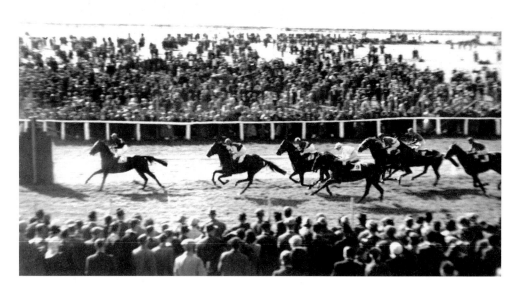

A race on the Back Strand: the first August Racing Festival held at Graun was in 1912 and the popularity of the new venue was shown by the readiness of Ireland's trainers to send their top-class horses to Tramore. In recent times the company name has been officially changed to the Waterford & Tramore Races and has ninety shareholders.

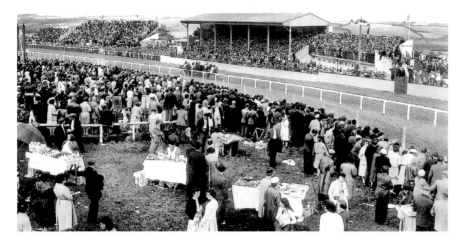

In the days when this picture was taken race-goers could go inside the track and this was very popular with families but eventually this had to be discontinued on the instruction of the safety authorities. The meeting on 1 January 2000 went down in history; it was the only meeting that day in the entire northern hemisphere, as all the others were fearful lest their computerised equipment crashed at the turn of the millennium. It was a lovely day and a record crowd of over 11,000 attended. The takings on the tote were over twice the previous record and the first race was won by Waterford jockey Shay Barry on No Problem.

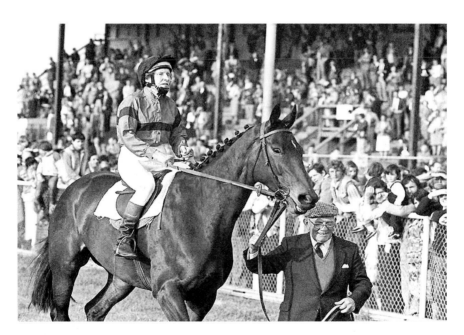

Waterford owner Charmain Hill on her famous Dawn Run as they parade before a Tramore audience. Dawn Run was the most successful horse in National Hunt racing as she was the only racehorse to complete the double of winning both the Champion Hurdle and the Gold Cup, both at Cheltenham. She was also the only racehorse to complete the Irish, English and French Hurdle treble. (Waterford & Tramore Racecourse)

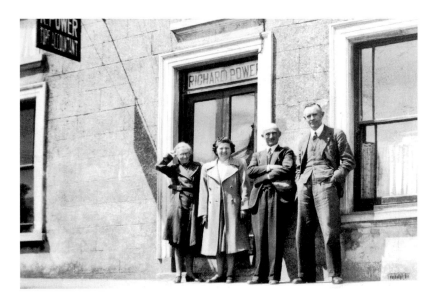

Richard Power, the famous firm of turf accountants (bookies to most people), started in Tramore in the 1940s. Control of Richard Power's many offices was exercised from here at The Cross in Tramore. Included in the picture are Noeleen Power (Richard's daughter), Maur Power (no relation but devoted employee) and Joseph O'Flaherty, who was also employed by the company. (Antonette Crehan)

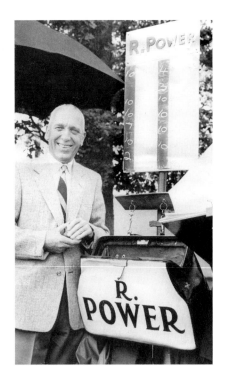

Paddy Power, son of the founder Richard, who took over from his father. The firm grew during the 1950s and '60s to 101 offices. On Paddy's death, his son David took over and it reached the fourth generation when it was passed on to David's son, Willie. The firm now operates betting online and at some courses, as well as having a shareholding in Paddy Power. (Antonette Crehan)

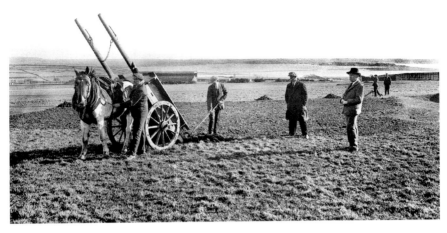

It was the great Tramore entrepreneur Martin J. Murphy who was responsible for bringing golf to Tramore. He took out a lease on Budd's Back Strand and transformed it into a race track, cycle track and golf links. In 1894 Tramore Golf Club was one of just a handful of courses in Ireland. Waterford city did not even have a golf club. Here workers are transforming waste ground on the Back Strand into a fairway. (National Library of Ireland)

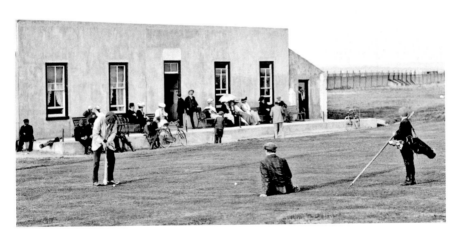

Murphy engaged an expert to lay out the golf course and a Scottish professional to coach the few initial members. By 1905 the membership had reached 250 (including thirty-one ladies and eleven juniors) and improved facilities, such as this clubhouse, were provided. The annual subscription was increased to 30s and for an extra 10s members could also shoot rabbits that inhabited the burrows. In 1906 a professional came to Tramore named Alf Toogood (couldn't go wrong there). He stayed for three years, during which he coached the players and greatly improved the course. (National Library of Ireland)

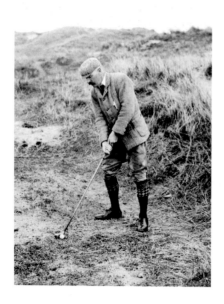

All the work on the course proved to be a waste when the bank burst in 1911 and the course was flooded. The golf club joined forces with the Race Company and in 1912 they both moved to Graun where a new nine-hole course was constructed in the centre of the race track. A wooden pavilion was built and later additional land was purchased and the course extended. But things were far from ideal. Space was tight and play had to stop during race meetings when the golf course also suffered damage.

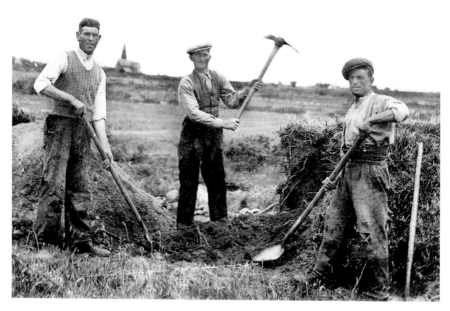

In 1936 it was decided to move yet again. Money was raised and farmland was purchased at Newtown. In November 1936 work started on creating the championship golf course still in use today. A large body of men was engaged to undertake the work according to the design of Captain H.C.C. Tippet of Walton Heath GC – a difficult and exacting task. (Padraig Cunningham)

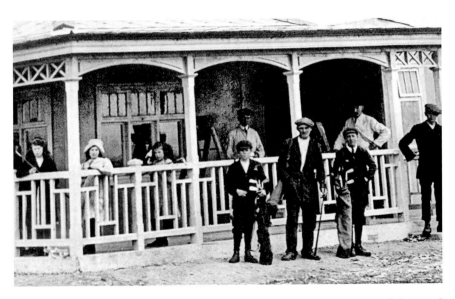

This wooden clubhouse was transported from the racecourse to Newtown and the grand opening of the new course took place in June 1939. A new, much-enlarged clubhouse was completed in 1970 and an additional nine holes were added in recent years, giving Tramore a total of twenty-seven holes.

Left: Billy Butler spent over fifty years with Tramore GC. He started off doing repairs to golf clubs and went on to become the club professional. Billy had the unique distinction of being associated with all three courses and at Graun his score was never bettered. He inspired many good players and died in 1983 at age 90. (Tramore Golf Club)

Right: Tommy Ryan also worked for Tramore Golf Club for over fifty years. He was heavily involved in the successful construction of the original eighteen-hole course at Newtown and was head green-keeper. In his youth he was a low handicap golfer. (Tramore Golf Club)

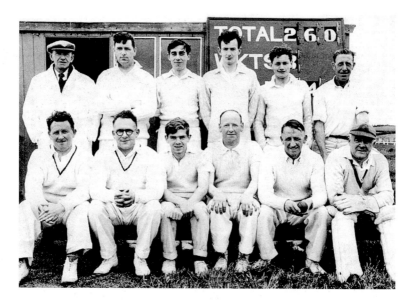

Cricket came to Tramore about 1873 on land at Ballycarnane owned by Congreve Rogers. Matches were well attended with afternoon tea served and music provided by the Waterford Artillery Band. However, Rogers abandoned cricket in 1880 and the locals had to resort to playing on the beach or wherever they could. The game became generally very popular and when the golfers moved out of the racecourse, the cricketers moved in with the actual racecourse forming the cricket boundary. Included in this Tramore 11 are, front row: Leo Higgins, Harry Elms, Master Power, Dermot Cahill, George Higgins and Cecil Higgins. Back row: Mr Murphy (umpire), Andy Collins, John Hogan, Freddie Kidd and 'Snozzles'. (Anne Keighery)

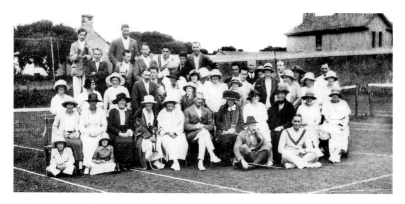

Tennis arrived to Tramore about 1880 and, as with all sport start-ups, pro tem grounds were found. Eventually proper grounds were presented to the club by Thomas Gallwey, who donated the site adjoining his family home Rockfield. This location, looking out over the bay, is quite idyllic. The club was officially formed in 1921. This photograph of a group on court one was taken in August 1922. The court surface was of course grass in keeping with the game's full title Lawn Tennis. (Gallwey Family)

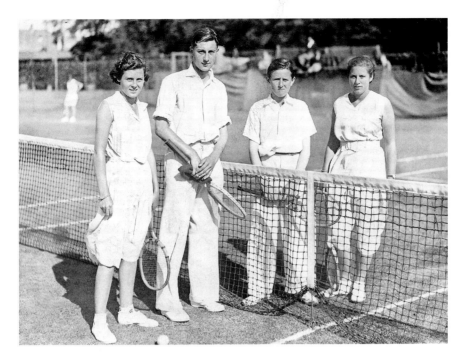

Tramore LTC had many good players including the teenage brother-and-sister mixed doubles partnership of Matty and Una Harpur, who are pictured here on right at Fitzwilliam in 1934. As may be gathered from Matty's facial expression, they lost. (Anne Harpur)

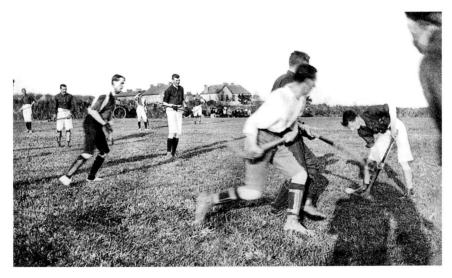

Field hockey came to Tramore in 1901 and in 1931 the Tramore ladies created history when they won the Munster Senior Hockey Cup by defeating Ashton (Cork) 1–0. At that stage they were using land at Priest's Road but in 1934 they moved to John Hally's land at Crobally (where the soccer club now is). Men played hockey also but to a lesser extent and picture shows the men in action. (Waterford County Museum)

Hockey on roller skates became popular in Tramore in the 1930/40s at the Palace, which later became the Silver Slipper Ballroom. Pictured here is the 1957 Tramore Ladies roller-skating hockey team. In front, from left to right, are: Joan Power, Bid Widger, Carmel Brophy; back Tessie Power, Tommy O'Regan, Rita Barnett, Winnie Butler. (Carmel O'Regan Crosbie)

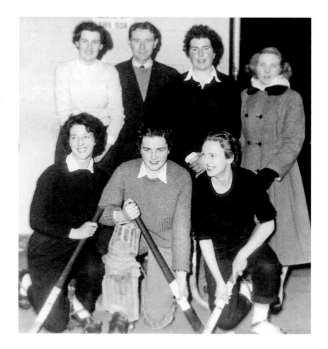

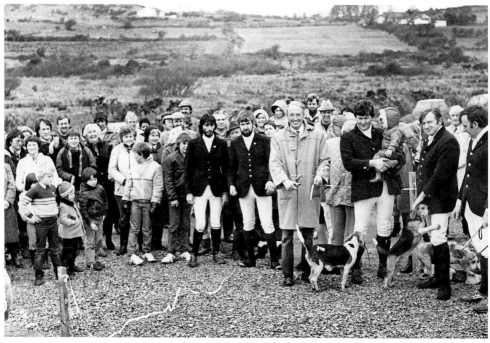

Cutting the tape in 1970 to open the new kennels at Carrigavantry for the Waterford and Tramore Beagle Club is Arthur Ryan from Holy Cross, County Tipperary, watched by Michael White, Ger Shanahan, Michael Sheridan, Oliver Power, John Hearn, Dan, John, Mary, Marion and Brid Cantwell, Brian Elms, Mini Whittle, Gerry and Nuala Rushe with their three children, Mary Shanahan and others. (Marion Cantwell)

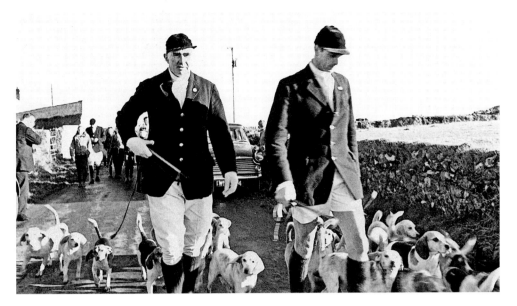

Fergus Power and Dan Cantwell lead off the beagle hounds. (Marion Cantwell)

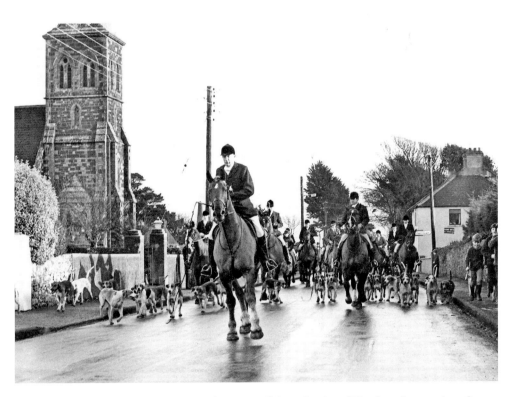

Traditionally, the Waterford Hunt always set off from the Grand Hotel on the morning of St Stephen's Day. They are seen here making their way out of Tramore to go in search of a fox. (Marion Cantwell)

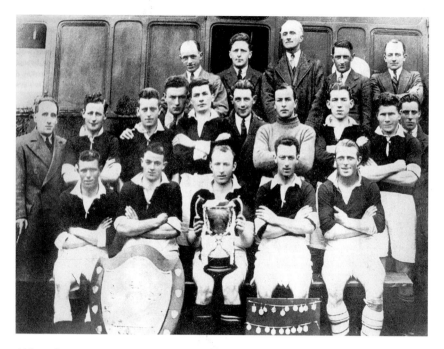

Although soccer was introduced into Tramore around 1908 by a Christian Brother from Belfast called McGuirk it did not progress very far until 1926, when a bunch of players defected from the GAA and formed Tramore Celtic, using a rented field. This new club did very well and won the First Division League within a year of its formation. Another group, called the Tramore Rookies, was formed in 1929 and wore black jerseys. Here they proudly display the George French Shield and Intermediate Cup, which were won in 1935. From left to right, back row: Eric Power, J. Bohill, B. Hally, T. Mills and J. Coughlan. Middle row: T. Long (trainer), J. Kennedy, G. Bishop, N. Winter, Jim Goodwin, D. Walsh, Jack Goodwin, J. Walsh, E. Kirwan and C. O'Brien. Front: M. Morrissey, M. Kiely, J. Dunne, J. O'Brien and M. O'Brien. (Tramore AFC)

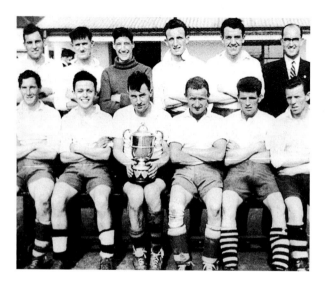

Tramore AFC was formed in 1952 and the team that won the Infirmary Cup in 1957 is pictured here. From left to right, back row: Tom Corcoran, Danny Linehan, Dick Power, Michael Brophy, Willie Kelly and Andy O'Beirne (chairman). Front row: Tommy Butler, Peter Halligan, Jimmy Kennedy, Dela Hayes, Joe Fitzgerald and Johnny Fleming. (Tramore AFC)

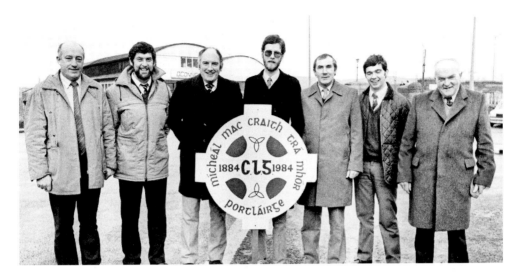

Tramore GAA club was formed about 1908 (although matches had been played on the Strand since 1855) with the strange name 'Isles of the Sea' and by 1920 hurling was introduced. In 1951 the new club took the name of the young Volunteer Micheal MacCraith, who lost his life in the ambush at Ballinattin in January 1921.

All games were played at rented pitches until their own ground was officially opened in April 1964 at Crobally, on 7 acres purchased from John H. Lodge. Patsy Flannagan, Jack O'Brien, Senan Power, Eamon Pollard, Tom Butler, Noel Ryan and Bob Power are pictured here celebrating the GAA's centenery. (Cumann Micheal Mac Craith)

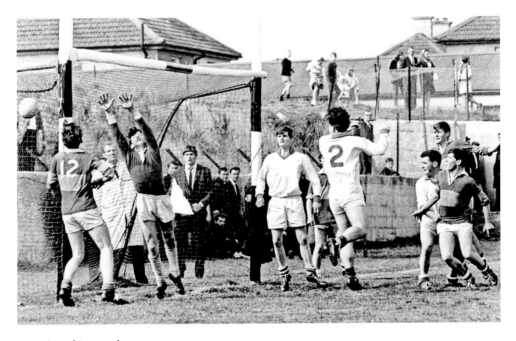

A goal is scored.

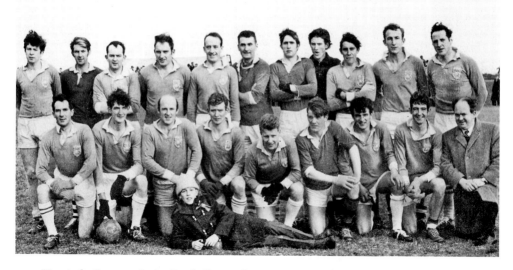

Here is the Tramore Senior Football team that, on 7 December 1969, greatly distinguished both themselves and Cumman Micheal Mac Craith at Fraher Field, Dungarvan when they defeated Geraldines of Aglish in a hard fought-match and so captured the Conway Cup for the first time. From left to right, front row: Tommy Butler, Mickey Fleming (Captain), Bernard Power, Ollie Fleming, Mick Mernin, Dougie Partridge, Sean Flavin, Billy Fleming and Tony Rockett (selector). Back row: Greg O'Neill, Pierce Mehigan, Pat O'Brien, Senan Power, Patsy Flanagan, Liam Kelly, Jim Walsh, Tommy Fleming, Mickey Cowman, Michael Power and John O'Brien. In front is John O'Neill. (Rory Wyley)

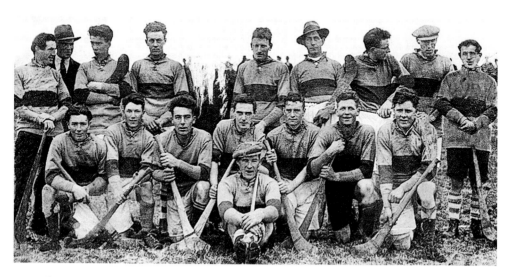

The junior hurling team of 1930. (Cumann Micheal Mac Craith)

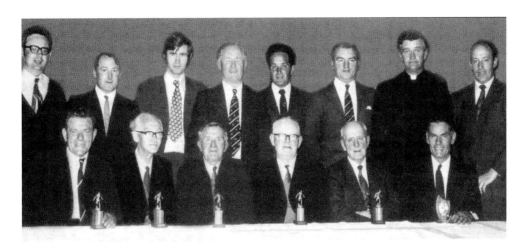

A presentation was made to founder members in 1973. From left to right, front row: D. Cowman, F. McGlynn, T. Barry, T. Brennan, N. Power, M. Cowman. Back row: D. Cullen, T. Kelly, J. Walsh, P.O. Fainin, M. Cowman Jnr, S. Grant, Father Liddane and P. Flanagan. (Cumann Micheal Mac Craith)

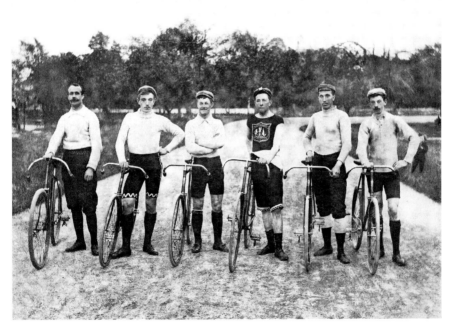

Members of Tramore Cycling Club in the early days. (Marion Cantwell)

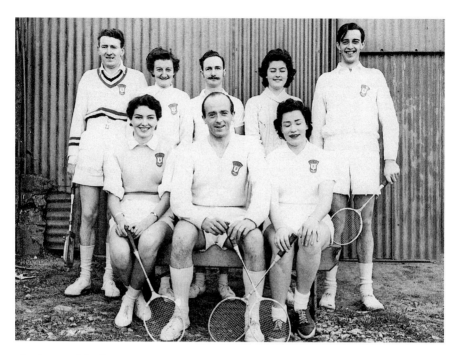

The home of badminton in Tramore was a converted garage at the Majestic Hotel. Here is a Tramore team from 1955/56. From left to right, back row: Paddy O'Neill, Pat O'Sullivan, Paddy O'Sullivan, Kathleen Hogan and Dan Cantwell. Front row: Nesta Fleming, Noel O'Neill and Audry Hughes. (Marion Cantwell)

Tramore girl Maisie Bishop was an avid swimmer and in September 1931 she secretly set the record for being the first to swim the 4-mile width of Tramore Bay. A boatman named Dunphy rowed her to Brownstown Head at 11 a.m. and accompanied her throughout, together with a school of inquisitive but non-interfering porpoises. Maisie reached the Metal Man in just two hours. Word got out and Maisie unwittingly became famous. She married Alvin Howard and they had a confectionery shop where the Slip Inn is now. Her son is Tim Howard of Richmond Terrace and her granddaughter Sarah inaugurated the Maisie Bishop Memorial Swim in aid of Hospice. (Tim Howard)

11

TRANSPORT AROUND TRAMORE

31 December 1960. As regards getting around Tramore, most people either walked or used a bike; distances are not great. However, there were other means of getting around available only to the privileged few, but nonetheless worth recording.

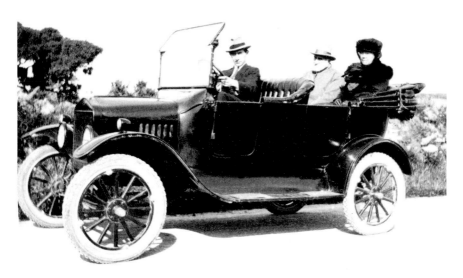

Jack Lodge at the wheel of his car with his father (John Senior) and his mother, Catherine. (Mary Jennings)

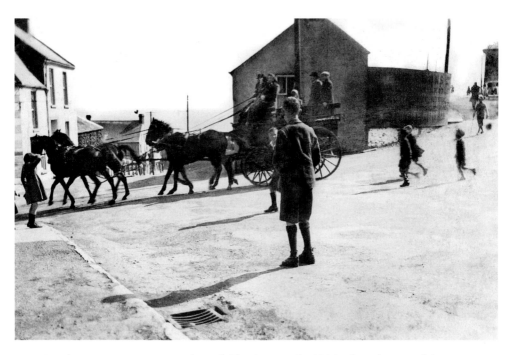

Four-horsepower taxi passing through The Cross in the 1930s. (David Kenneally)

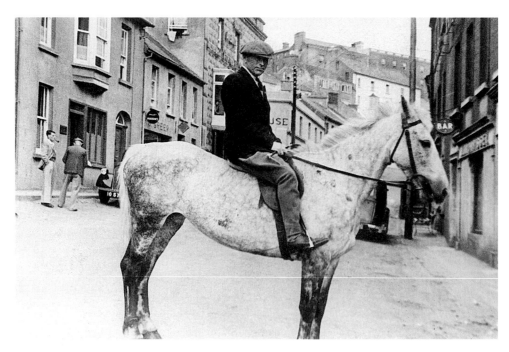

Paddy Crehan thought nothing of parking in the middle of Strand Street. (Antonette Crehan)

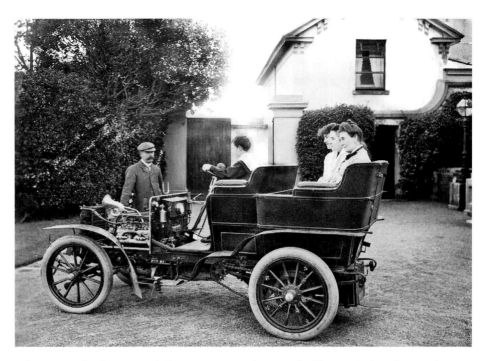

What was said to be Tramore's first motorcar is photographed here in 1903. The proud owner is William Gallwey while young Thomas is at the wheel and other family members are behind. (Gallwey Family)

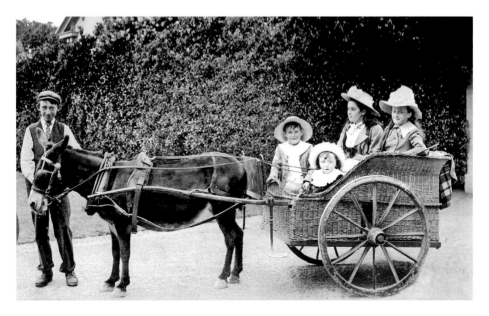

A non-mechanical mode of transport shows a donkey pulling a basket-type cart to convey very young members of the Gallwey family at Rockfield under the watchful eye of the young man in charge. (Gallwey Family)

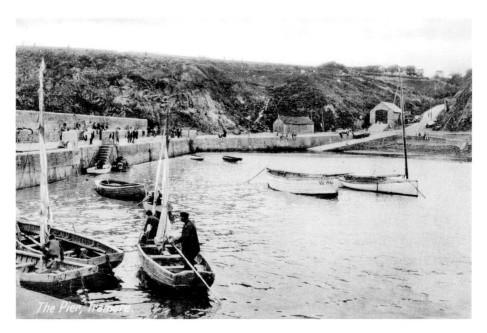

Of course, boating is a natural means of transport at the seaside and gets people around to the Strand and the various bays. (Norma Boyle)

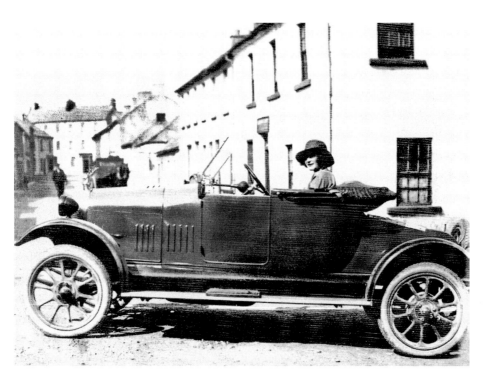

It's May 1922 and this stylish lady has her roof down as she waits outside Croke's – said to be one of Tramore's oldest pubs. (Philimena & Micheal Croke)

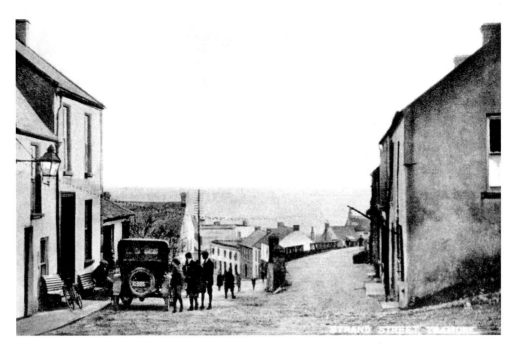

This car on Strand Street seems to have been a curiosity. (Thomas Jones)

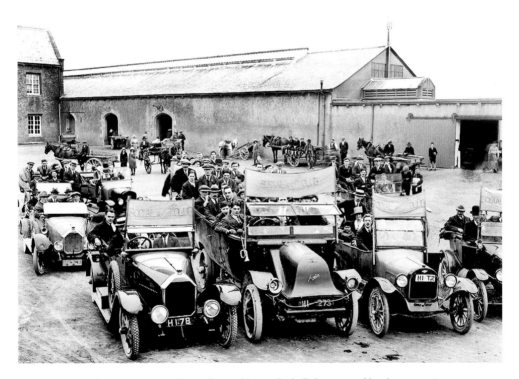

A group of car lovers came from Clonmel to avail of all that is good by the sea in Tramore.

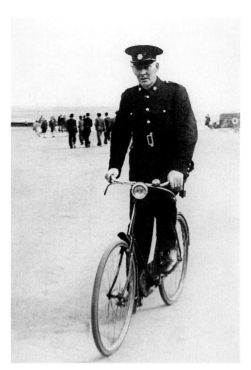

Garda Sergeant Dan Begley used his sturdy bike to get around when on patrol. (Waterford County Museum)

This ice-cream vendor used a motorbike. Others had a tricycle with the ice cream in a large box in front, alternatively a tractor or van. (Philip Jacob)

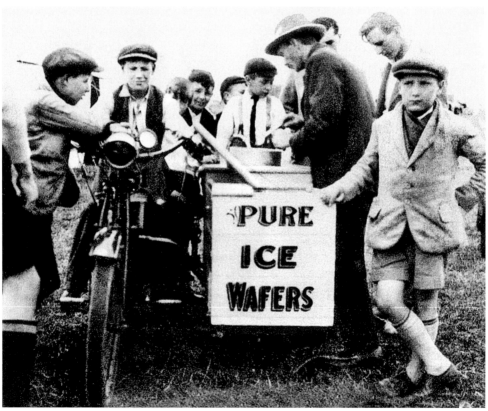

PUBLIC FIRST AID POST

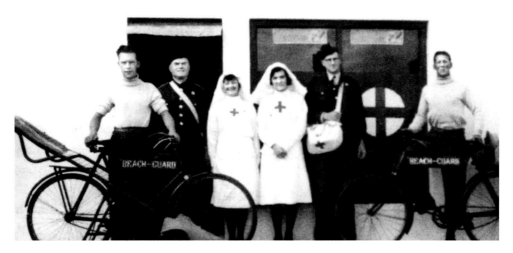

Beach Guards with their bikes at the Red Cross centre in 1945. (Philip Jacob)

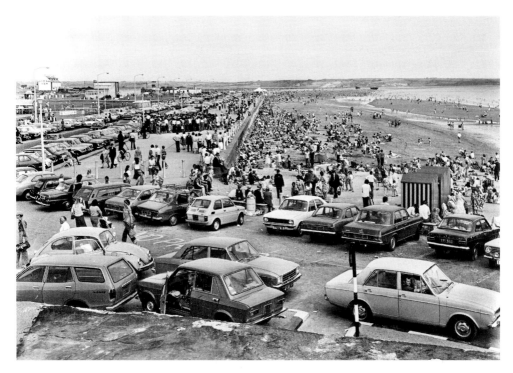

The absence of the train in the 1970s resulted in a lot more cars coming to Tramore, especially on a Sunday. (Marion Cantwell)

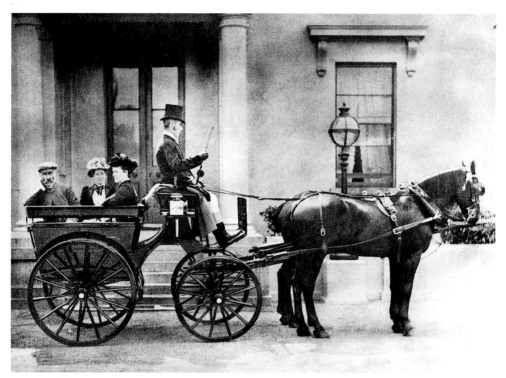

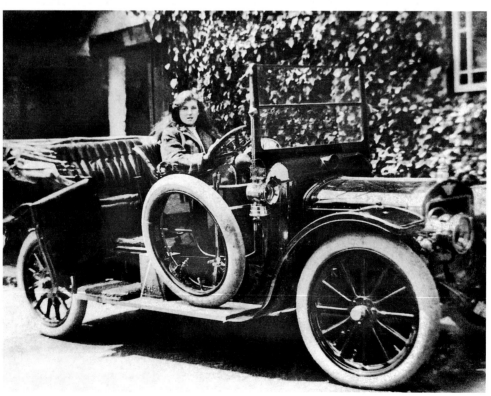

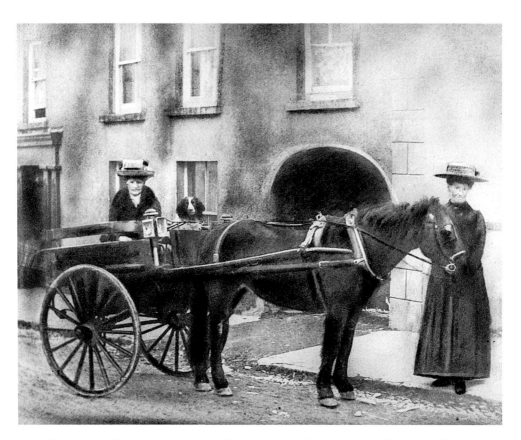

The pony and trap was always reliable and is seen here on Queen Street, outside the archway leading to the ball alley. This alley was originally intended for use for playing the game of rackets, much loved by Queen Victoria, and this made it popular during her reign. It is also probably the origin of the name Queen Street. Later it was used for handball and Sam Morris, a competent handballer himself, owned the ball alley in the 1940s and encouraged others to play the game. (Paul Horan)

Opposite top: It's 1893 and William and Frances Mary Gallwey with a friend are ready to leave Rockfield on Church Road with two horses and a very smartly attired driver. That was an age when social judgements were made on the basis of the turnout of servants, horses and carriage. (Gallwey Family)

Bottom: A lovely lady in a lovely car – Nora Kenny at the wheel outside Belaire in June 1912. (Gallwey Family)

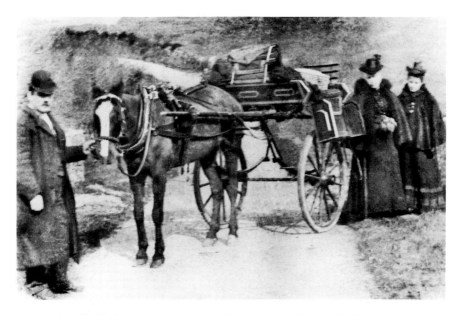

Unique to Ireland, the jaunting car was the taxi equivalent, with the passenger seats facing sideways and capable of accommodating up to four. Jaunting cars are still very much in use in Killarney and are a major tourist attraction – they are to Killarney what the cable-car is to San Francisco.

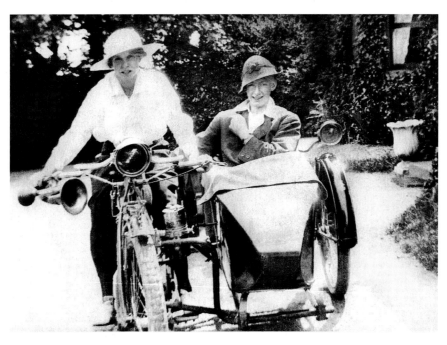

Nora Kenny on a motorbike in June 1916 with her friend Wilfred Burke in the sidecar – this photo was taken in the front garden of Belaire on the Old Waterford Road. (Gallwey Family)

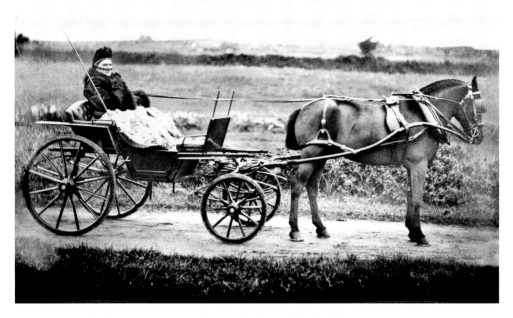

Mrs Murphy from Queen Street. (National Library of Ireland)

Sitting on the running board in front of the kennels (home of the Beagles) in 1928 are a lady, a little girl and their dog who seems anxious to become a Beagle.

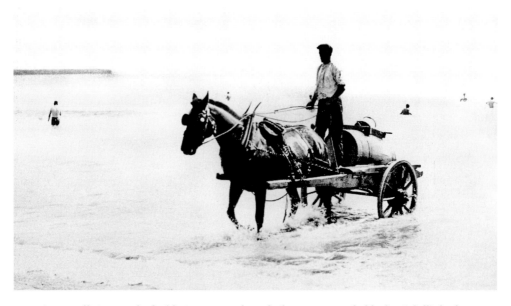

A very efficient method of bringing in a barrel of seawater, probably for Cahill's baths. (Andy Taylor)

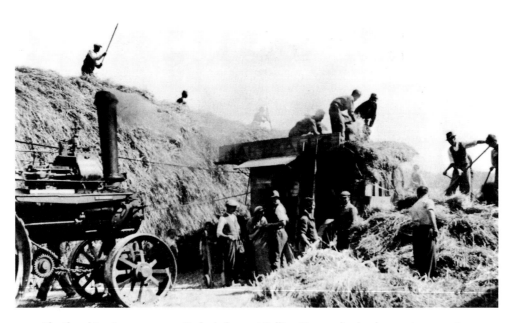

The threshing in progress on Lodge's farm at Ballinattin way back when a steam engine was used to power the threshing machine and tow carts as well as other farm items. (Mary Jennings)

12

TOPICS OF HISTORICAL INTEREST

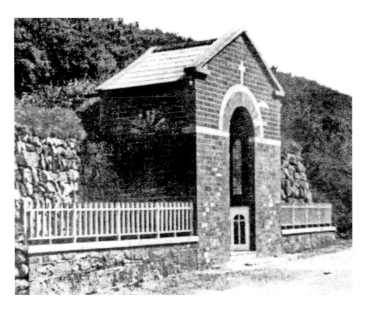

This shrine in Ballinattin marks the spot where a skirmish (known as the Pickardstown ambush) took place in January 1921 during the War of Independence. A minor attack was staged on the RIC barracks in Queen Street while the bulk of the IRA force waited at Pickardstown to ambush British Army reinforcements coming to the rescue from Waterford. However, an IRA gun was fired prematurely and the British troop convoy (which consisted of four lorry loads and not two as expected) stopped ahead of the trap that had been laid. After an exchange of gunfire, the attack failed and IRA volunteers Micheal MacCraith and Thomas O'Brien lost their lives. The GAA grounds in Tramore and Dunhill are named after them. (Waterford County Museum)

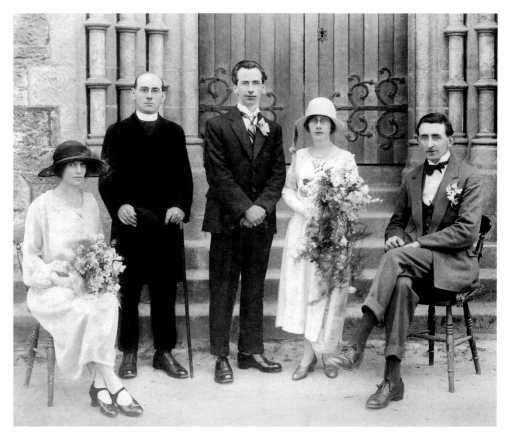

During the Pickardstown ambush, another volunteer named Nicholas Whittle was shot three times and was assumed dead by the British. But he managed to crawl away and, despite the three bullets in his body, he walked 5 miles towards Gaultier, got shelter and medical attention and was eventually taken to a safe house in County Kilkenny and on to England. Nicholas is photographed here on the occasion of his marriage in 1925 to May Troy whose folks owned Troy's Hotel (later The Boolabawn) on The Terrace. The celebrant was Fr John Whittle – brother of the groom and home from England where he had concealed Nicky when he was on the run. The bridesmaid was Frances Hughes and best man was Sean Quilter. (Breda Ryan *née* Whittle)

Right: This picture was taken on Remembrance Day (then called Armistice Day), probably around 1924, at the graveyard in front of Holy Cross church when a wreath was laid at the grave of Naval Seaman Cahill by Thomas H.E. Gallwey, Chairman of the Ex-Servicemen's Association. Behind the lad in front holding a cap is Michael Power and the smaller boy to the left of him is 'Fairy' O'Brien but little else is known regarding the photograph. (Gallwey Family)

When war was declared in 1914 many in Waterford followed the advice of their MP John Redmond and joined the British Army. His logic was that, by helping Britain, Ireland would be assured of Home Rule. Pictured here is Tramore's Thomas H.E. Gallwey saying goodbye to his mother before leaving for the war. He fought in the Battle of the Somme, which resulted in over 420,000 casualties during 147 days. He was wounded and walked with a limp for the rest of his life. (Gallwey Family)

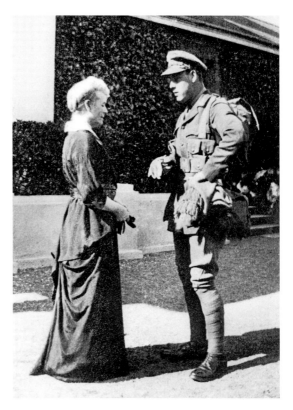

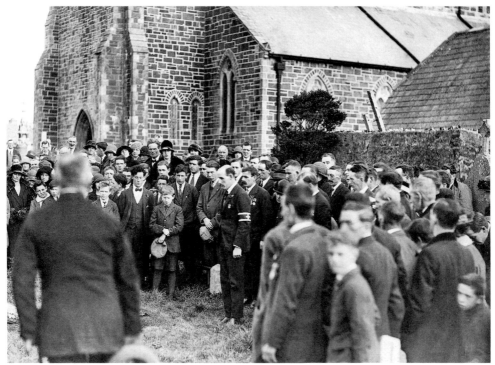

Left: During the Second World War there were look-out posts all along the coast with one positioned at either side of Tramore; to the east was the one pictured here (No. 17) at Brownstown Head and to the west was No. 18 at Dunabrattin. Their job was to raise the alert if combatants entered neutral space. During the six years of the war, Tramore experienced a good deal of air activity. On Sunday 23 August 1942 Tramore witnessed aerial combat over the bay. It involved two RAF Spitfires getting the better of a German Messerschmitt. Eventually the Germans landed their badly damaged plane in a field in Tourgare owned by Owen Power. It exploded but the four Germans had got out safely and were given breakfast by the Powers. After doing a few 'victory rolls' the Spitfires returned to Wales. The Germans were probably interned in the Curragh for the war's duration. (P.J. Cummings)

Above: Having limped along the Irish south coast gradually losing height as a result of damage inflicted by a British convoy which the Luftwaffe were attacking (and had sunk one tanker), this bomber had to crash-land just west of Tramore near Bunmahon, where it hit the ditch in one of John Halley's fields. One of the five crew members had a badly injured arm and this was repaired at the army military hospital at the Curragh. The Germans were interned and *Sonderfuhrer* George Fleischmann remained in Ireland after the war was over. (Millitary Archives' Private Collection)

Opposite top: The Knights of Malta came to Tramore in 1945 and have been serving the town magnificently ever since. Tramore Town Commissioners gave them a site on which to build their own HQ and Brendan Corish, Taniste and Minister for Health, is seen here on 16 June 1974 performing the official opening with Officer-in-Charge Paddy Godfrey on the left and Knights Pears Sinnott and John H. Lodge on right. (Mary Jennings)

Bottom: Knight Dayrell Gallwey presenting a medal to Nurse Ann Flynn (both since deceased). As a tribute to her, the ambulance currently in use in Tramore is dedicated to this marvellous nurse. (Gallwey Family)

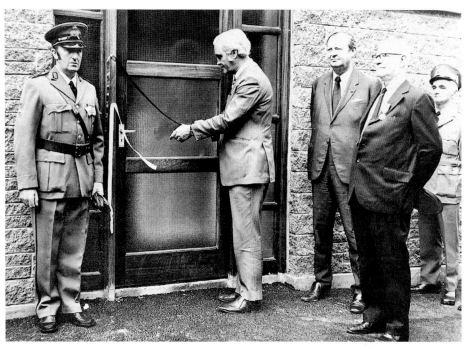

Since 2009 the Order of Malta Ambulance Corp in Tramore has been concentrating very much on cardiac first response (CFR) and is frequently called into action following a 999 call. Cadets are seen here with Commander (to give him his title on retirement) Paddy Godfrey and Nurse Ann Flynn. (*Waterford News & Star*)

Opposite top: In 1948 Tramore Town Commission was formed and the first commissioners are pictured here. From left to right, front row: Charles S. Jacob (vice chairman), Simon Moynihan (county manager), Eric Power (chairman). Middle row: Michael Morrissey, Ellen Hynes, Tom Casey (town clerk), Joseph O'Flaherty. Back row: Eddie Halley, Sam Morris, Jack O'Brien and Sean O'Higgins. By June 1955 they had saved enough from town charges to purchase Tramore House and its magnificent gardens from Mrs Winifred Hamilton for £3,500. The National Roads Authority now use the house as offices and the garden has been beautifully redesigned as the Lafcadio Hearn Japanese Gardens which were opened to the public on 26 June 2015. (Philip Jacob)

Bottom: Patrick Hearn was born in 1850 on the Greek island of Lefkada to an Irish father (a surgeon in the British Army) and Greek mother. They split up when he was just four and he was cared for by his grand-aunt, Sarah Brenane. Patrick attended boarding school in England and loved coming back to Tramore where he developed a lifelong love of the sea. He became a journalist in America and at the age of 40 he was sent on an assignment to Japan. He was captivated by the country and stayed there, marrying Setsu Koizumi and changing his name to Lefcadio Koizumi. He spent the rest of his life lecturing and writing on his adopted country. The beautiful Japanese gardens being developed in his honour in Tramore are expected also to become a place of pilgrimage not only for Japanese people who revere Lefcadio but also for those who wish to enjoy all that the garden has to offer. (Agnes Alyward)

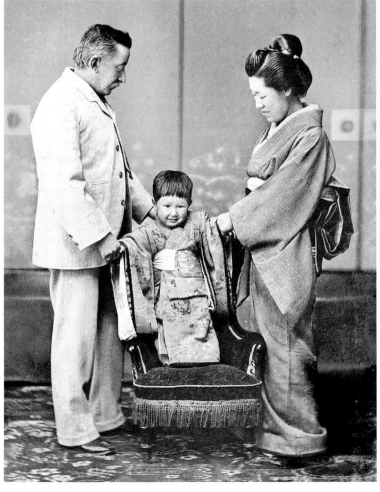

History was made for Tramore in 1992 when the President of Ireland, Mary Robinson, and her husband Nick visited the town. This was the first time that Tramore was honoured in such fashion and the President graciously came in response to an invitation by Tramore Town Commissioners. She met many people and addressed a large gathering in the CBS hall. Amongst those who attended was Thomas Reddy (seen here with the President) who was a Town Commissioner for twenty years.

Below: The President is pictured here after signing the visitors' book in Tramore House with (seated) commissioners Frank O'Donoghue (chairman) and Maureen O'Carroll and (standing) the chairman of Waterford County Council and commissioners Tom Healy, Brian O'Shea, Con Casey, Dan Hurley (county manager), commissioners Billy Hutchinson, Dan Cowman, Maura Clarke-Rellis, Brian McNally (county secretary), Sean Brennan and John O'Sullivan (town clerk).